ONE Watercolor A DAY

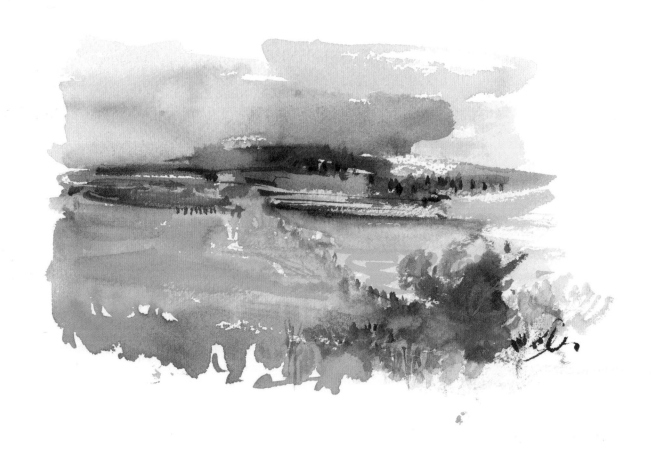

Field in Arles, by Veronica Lawlor, watercolor on Arches cold-pressed paper

ONE
A DAY

A 6-Week Course Exploring
Creativity Using Watercolor,
Pattern, and Design

VERONICA LAWLOR

Quarry Books
100 Cummings Center, Suite 406L
Beverly, MA 01915

quarrybooks.com • craftside.typepad.com

First published in the United States of America in 2013 by
Quarry Books, a member of
Quayside Publishing Group
100 Cummings Center
Suite 406-L
Beverly, Massachusetts 01915-6101
Telephone: (978) 282-9590
Fax: (978) 283-2742
www.quarrybooks.com
Visit www.Craftside.Typepad.com for a behind-the-scenes peek at our crafty world!

10 9 8 7 6 5 4 3 2 1

ISBN: 978-1-59253-857-7

Digital edition published in 2013
eISBN: 978-1-61058-911-6

Library of Congress Cataloging-in-Publication Data available

Design: Veronica Lawlor and Dominick Santise
Cover Image: Studio 1482

Printed in China

Flowering Tree, by Veronica Lawlor, watercolor

Hudson Valley, by Dominick Santise, watercolor

Contents

INTRODUCTION

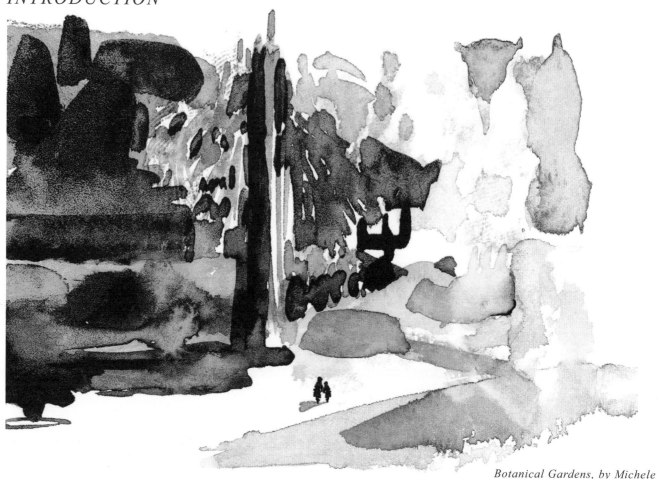

Botanical Gardens, by Michele Bedigian, watercolor, digital

THIS IS A WATERCOLOR book that will not teach you how to paint with watercolor.

Wait! Before you put the book down, let me finish. What I *mean* to say is, this book will not give you step-by-step lessons about how to paint a specific picture with watercolor paints in a specific way. What it *will* do is offer exercises, tips, and suggestions for playing with watercolor paint and finding your own way to work with it through your own hands-on experiences. After all, the beauty of watercolor paint is that it's based in water, isn't it? That flowing, mercurial substance that has fascinated artists forever:

Leonardo DaVinci filled sketchbook pages with drawings of it. If "the medium is the message," as Marshall McLuhan so famously suggested, perhaps the message of watercolor is simply *let it flow*. Be open to it; experiment with it; allow it to lead you through many, many pictures. That kind of experimental approach to art is the kind of approach favored by myself and the other artists of Studio 1482, an illustration and design collective in New York City. We believe in art as an exploration of what you haven't yet done or tried—art as study; that's what keeps it moving forward. With that in mind, we like to study our work as much as possible, and a

few years ago, we created the blog, *One Drawing a Day*, so we could post our studies and experiments to share with each other and the world. The blog became a book by the same name; now we are focusing our efforts on one artistic medium with many creative facets: watercolor.

And that's where this book begins. Based on the experiential philosophy of our book *One Drawing a Day*, and using our own work as a point of departure, this book will lead you through forty-two exercises to guide you through working with watercolor. In the process, we'll talk about paper, brushes, and various techniques and approaches that you can try, with the final aim of creating a comfort level with the medium that will allow you to continue using it to express yourself in a very personal way. We'll talk about using watercolor directly, in combination with other materials, and as a preparation tool of study for other projects such as ceramics and textile. But mostly, we'll ask you to use watercolor. The best way to learn something is to *do something*—if you want to learn to swim, you've got to jump into the pool; if you want to play the piano, you've got to touch the keys; and if you want to learn to paint with watercolor, you've got to dip your brush in the paint and get started. Be open to mistakes and, most important, leave any critical self-judging at the door.

Why is it that people who decide to pursue art, whether as a hobby or profession, place such high expectations upon their early efforts? I have heard so many people say to me, "I can't even draw a straight line," which makes me ask, "Do your really need to? We have rulers to help you with that!" Your first painting is just that—your first painting. You *don't know yet* how good you could be. Art is a process, like any other. No one expects to hop on a bicycle and just start riding as if they've been doing it all their life, yet we somehow feel that

if our first painting isn't up to our own high expectations, we should stop, we are not an artist, and we should leave painting to the gods of art who reside in museums around the world. Well, guess what, they were human too. So let's allow for our own humanity and not expect genius paintings the first time we pick up the watercolor brush. Instead, I'd rather we allow ourselves to enjoy the painting process. If some of the exercises in this book seem difficult, I encourage you to give them your best shot and see what can happen. The best part of art is not knowing where it's going, but having fun getting there. And for those of you readers who are experienced or professional artists, I hope this book can give you a little jolt into some new ways of thinking and playing with the watercolor medium. It's always nice to have an outside voice making suggestions toward our art—we need that input to keep ourselves fresh. That's one of the reasons that the Studio 1482 members came together and created our One Drawing a Day blog—so we can see what the other is doing in their art, bounce ideas off each other, and support each other with suggestions. It's been a great ride!

In our book *One Drawing a Day*, the artists of Studio 1482 encouraged you to play with drawing, to live with it, make mistakes, and see what would come out of it. We now encourage you to do the same with the watercolor medium. And what we hope comes out the other side of your experience with this book is satisfaction and joy. Isn't that why we make art, *really*, for the sheer joy of it?

So let's get this thing going

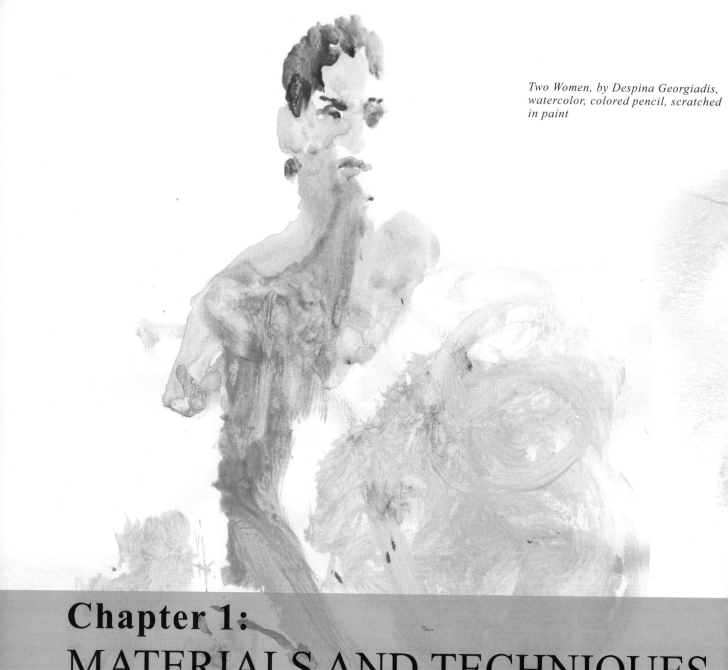

Two Women, by Despina Georgiadis, watercolor, colored pencil, scratched in paint

Chapter 1:
MATERIALS AND TECHNIQUES

What You'll Need

Before you begin the exercises of this book, you'll need a few supplies.

PAINT Watercolor paint comes in tubes or in pans. The tube paint squeezes out as pure color and can be mixed on a palette or used straight from the tube for the most vibrancy of hue. Pan colors are convenient for location work, and if you wet them down enough, they can become almost as vibrant as the tube paints. I recommend purchasing a set of pan colors, at least twenty-four, and several tubes of paint. You'll want minimally all of the primary and secondary colors, as well as a little tube of white for semiopacity. Pick a few more colors based on your taste, for variety, if you can afford to. You don't need grays unless you want to buy them: Mixing colors with their complements will gray them down considerably. Paints come in student and professional grade: Purchase the one that fits your budget. If you are on a budget, purchase more colors of student-grade paint and fewer colors of the professional. A small plastic palette that closes (good on location) will be important as a surface to mix paints on. You can squeeze your tube paints onto the palette, and rewet them each time you work. A small spray bottle of water is also helpful, to wet both your tube paints and pan paints before you begin to work.

You will also need a few tubes of gouache, an opaque water-based paint. Purchase the three primaries and secondary colors for mixing, plus white, and a few other colors by taste.

BRUSHES You'll want several different sizes and types of brushes to work with. Pure sable is the best; if that's beyond your budget, try a mixed sable and synthetic or a good synthetic. I rely mainly on three round brushes: one small (size 3 or 4), one medium (size 10 or 12), and one large (size 22). Look for brushes that have a sharp point and flexibility—the shape should pop back easily when snapped. You'll also want two flat brushes, one large for color washes and one small for blending or lifting off colors from the page. Pick up a fan brush as well for blending if you'd like, for fun.

PAPER Watercolor paper comes in sheets, in pads, or in a block. Try a few finishes in sheet form and then buy your preference. Sheets give you a chance to buy one at a time, pads can be convenient, and the block is nice for painting with a lot of wet washes because it will hold the paper tight and keep it from buckling. Heavier paper buckles less, too, and stands up to a lot of scrubbing. You can also tape your watercolor paper down to a board if you want to avoid buckling: Let the painting dry before removing your work from the board.

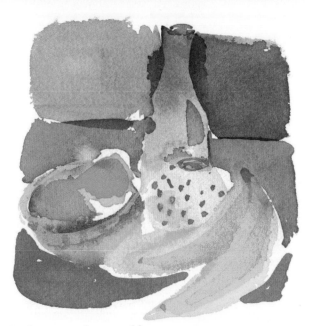

Study, watercolor on cold press paper

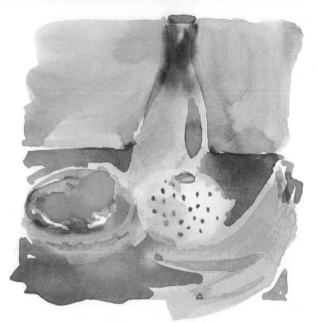

Study 2, watercolor on hot press paper

Watercolor Paper

Watercolor paper comes in three finishes: hot press, which has a smooth finish; cold press, which has a rough finish; and rough, which has the roughest finish (twice as much as cold press) and the most texture. The two studies above were done in Arches Aquarelle Watercolor paper: The one on the left was done on cold press, and the one on the right was done on hot press. You can see the difference in the finish by looking. Cold press will give you a more textured feel, and the paint spreads easier, making brushstrokes less visible. Cold press gives you that "watercolor paper" look. (The Aquarelle Rough Grain paper will enhance that even more.) Hot press is smoother, and the paint lies on the surface; less of it is absorbed. The paint spreads less on hot press paper, and brushstrokes can become more visible in a large area of color, as you can see in the teal background of my little study at right. You may prefer hot press when you plan to do a lot of layering, or lifting off paints, or when you want more vibrancy of color that comes with less absorption. You may prefer cold press for a more spontaneous feel and textured look. Get a few sheets of each paper finish, and do a few studies to see what suits you best. Papers come in different weights: The heavier weights are best for paintings with very wet washes, with layers, or when you'll be doing a lot of lifting off and repainting of colors.

SOME EXTRAS Other art supplies you'll need include a few 2H pencils, an eraser, a handful of colored pencils (or watercolor pencils), and a small jar of masking fluid. Something fun, but not essential, would be a few bottles of Dr. Martin's concentrated dyes; these are brilliantly colored dyes that you can add to your paints or use alone. You will also need a razor-point pen or a small bottle of waterproof ink and a dip pen for one or two exercises in this book. Last, a small set of Caran d'Ache water-soluble crayons will be needed for several of the exercises: Try to purchase a small set of at least twelve crayons.

Let's Talk Color

The color wheel illustrates how colors mix to create other colors. Creating color by mixing paint is known as the *subtractive* color system. In the wheel below, you'll see the three primary colors marked with an (A): Yellow, Red, and Blue. These colors are the basis for all the other colors on the wheel.

Mix two primaries to get a secondary (B) color: Yellow + Red = Orange; Red + Blue = Violet; and Blue + Yellow =

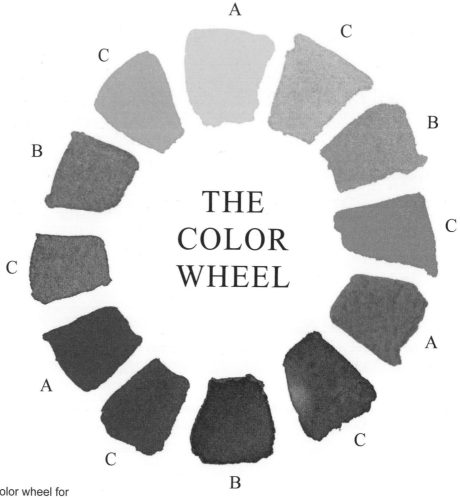

THE
COLOR
WHEEL

TIP

Try making a color wheel for yourself before beginning the exercises in this book.

The Color Wheel breaks color down into three groups: primary, secondary, and tertiary; watercolor

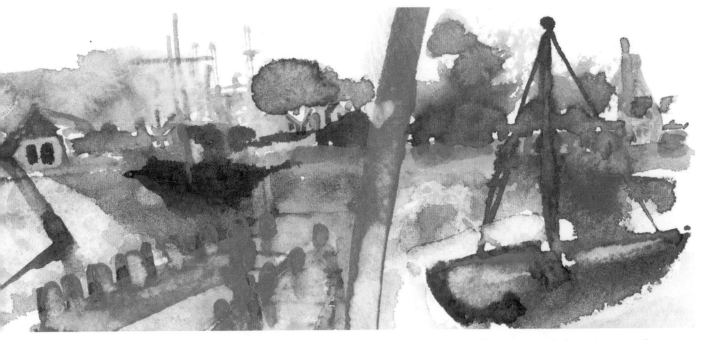

Green. You'll see that the secondary colors live in the halfway position between each primary. Mix a primary with a secondary color to get a tertiary color (C). The tertiary colors are Yellow-Orange, Red-Orange, Red-Violet, Blue-Violet, Blue-Green, and Yellow-Green.

Colors that are next to each other on the color wheel are analogous: for example, Yellow-Green, Yellow, and Yellow-Orange. Opposing colors on the wheel are known as complementary: for example, Red and Green. And each color has what's known as its split complementary: for example, the split complementaries of Blue are Yellow-Orange and Red-Orange. The complementary of Blue is Orange, so its split complementary colors sit on either side of the Orange panel. You can be very deliberate with these color "systems" when you paint, as you can see in Michele's beautiful example of a limited palette painting above. For an image of tranquility in Newport, Rhode Island, she used only two primaries and a secondary: Blue, Yellow, and Green.

Abstraction, watercolor on paper

Let's Paint

EXERCISE 1

Before we begin our exploration of watercolor, we first have to (literally) get our hands a bit dirty. For the first exercise in this book, we are simply going to experience the aesthetics of watercolor and begin putting paints down on the page. Paint them with a brush, drip them, throw them! Channel your inner Jackson Pollack, as Eddie has done in this series of paintings.

You might try different combinations of colors. Eddie's abstract painting at left is predominantly reds and blues, with a little yellow dropped in for a pop of something else. Try all kinds of combinations: greens and browns; purples, oranges, and yellows; pinks and grays with blacks; and so on.

Take some time with this, and create a lot of different combinations. You might even cut them out like little swatches of possibilities. A book such as that could be a wonderful thing to look back at as a self-reference of color. Don't be afraid to "waste" the paints. Getting familiar with your materials is never a waste of time or paint, but an exercise that pays off in the long run.

TIP

Put all of your colors in front of you before you start this exercise. Having them in easy reach allows your color taste and intuition to take over.

Color Swatches, watercolor on paper

Two Flowers

"Looking into a tulip. The first watercolor is wet on wet. A spreading experience! The second watercolor is wet on dry. A more defining experience! Both offered me a very different experience and result—hard to pick a favorite. Although to be honest, I do like making a lot of marks and giving definition." —Margaret

Tulip, wet-on-wet watercolor

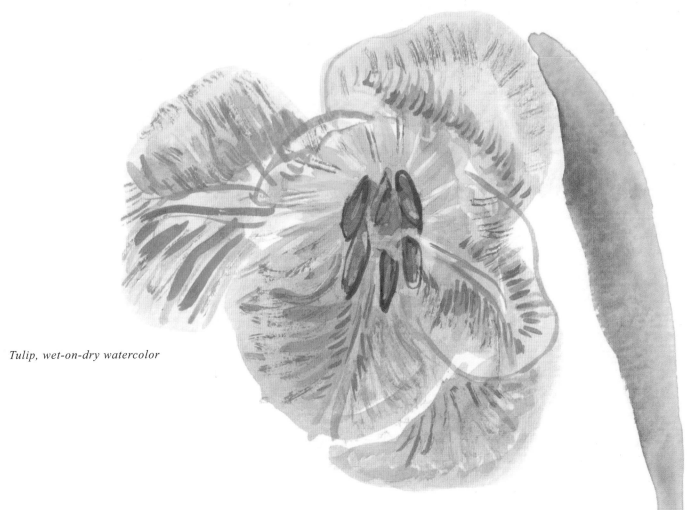

Tulip, wet-on-dry watercolor

EXERCISE 2

Choose one flower, such as a tulip, and make two paintings of it. For the first painting, we will do a wet-on-wet technique. What this means is that you first wet the paper and then apply your paint to the wet paper before it dries. You can add some details, but not too many, because too much pigment on the wet paper will start to get muddy. Look at how Margaret has added a few pink lines and the green and yellow ochre shapes to her initial washes of color. For the second painting, you will work with wet paint on a dry sheet of paper. Add details on top of the washes after the initial flower shape has dried. Hot or cold press watercolor paper can work for this exercise, although the cold press will allow the wet-on-wet color to spread a bit more. Notice the difference in the feel of the two techniques. You can use this knowledge in many of the exercises in this book.

Red

"This image is a little somber maybe, but it's a part of an ongoing project of mine about dreams and psychology. Some say the feeling of a dream is more important than the event: Color is the ultimate way to convey feeling, I think.

I tried to get different colors to appear by using just one color. I did this by placing different temperatures of the same color next to each other. So where it looks like there's violet or orange in a spot, when isolated, those areas are actually very red."
—Despina

VARIATION

After you've played with your red dreamscape for a while, try going outside and doing a different landscape—with all greens. It could be as elaborate as the Central Park watercolor that Despina has done here, or a simpler picture, such as a spot in your backyard or a potted plant on your windowsill.

EXERCISE 3

Today's exercise is a monochromatic painting of a dreamscape. We'll play with the range of the color red, as Despina has done. Create a picture in your mind of a dream image that feels like the color red. Keep it fairly simple so you get more involved with the color experiment than with the picture design. It doesn't have to be an entire scene from a dream you've had; it can be a detail. Create your basic shapes with a light pencil line, and start filling in the reds. To create variation, add a small amount of other colors to your red. You might try a little blue for dark areas, yellow for lighter tones—try them all. As you add these colors, notice not only how they affect the hue of your red, but also pay attention to how colors affect each other when juxtaposed. Experiencing color is the best way to learn it.

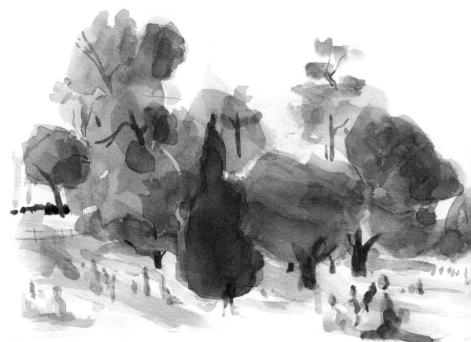

Central Park Scene, watercolor

Red Mono, watercolor on paper (opposite)

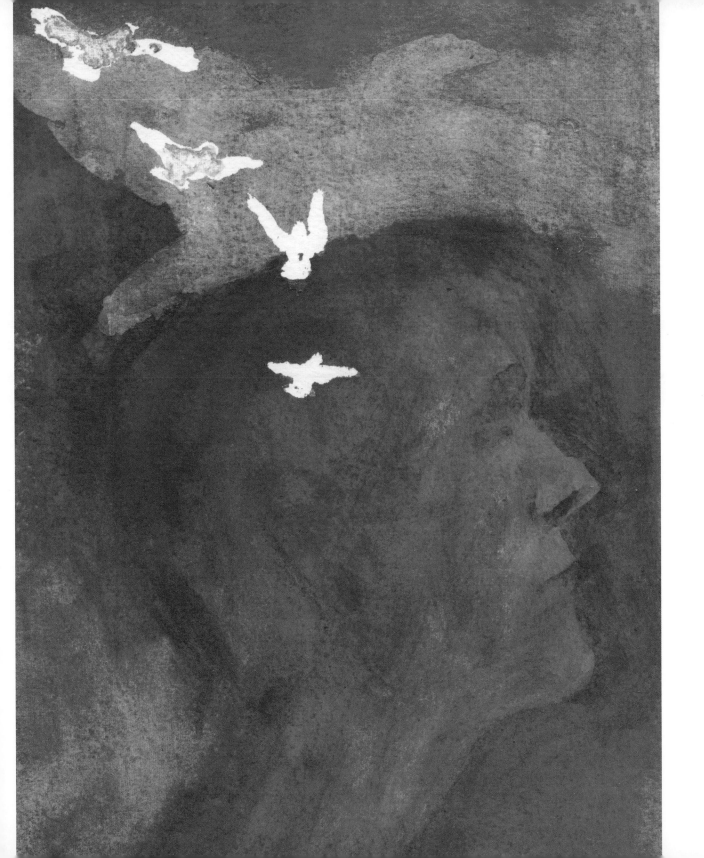

Color Studies

"This is much more controlled than the way I usually paint. But it was fun to experiment with color systems and do a few little studies. You can see the difference in the final feeling of the painting. Now I just have to apply this kind of thinking to my home décor!" —Veronica

Monochromatic painting in yellow: This is also the first layer of the analogous painting. Notice how I lifted the color off the page in the shape of the light round vase. Watercolor

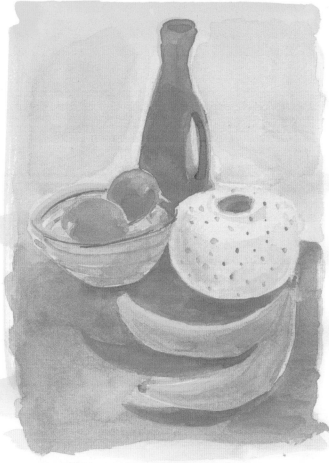

Analogous painting: This painting is restricted to yellow-orange, orange, and red-orange. These colors live next to each other on the color wheel. Analogous paintings can be very soothing. Watercolor

EXERCISE 4

Create a simple still life, and make a few studies in watercolor, trying different color systems. Here, I've used monochromatic, analogous, and split complementary color schemes. Put the paint down in layers, allowing them to dry in between, building your colors up slowly. Keep your color wheel in front of you as a reminder!

Lifting off technique, watercolor

TIPS

The analogous painting uses a technique called "lifting off." I didn't like the way the orange spread in my initial painting of the shape of the tall vase (top left). Once the paint dried, I wet it again and lifted the pigment off the page with a small flat brush to create a smoother edge (top right).

For these studies, I used Arches Aquarelle Hot Press watercolor paper. It gave me a smoother finish for layering and was more forgiving of the slight scrubbing I had to do to lift the unwanted orange bleed marks off the page. But don't overscrub, or you will end up disturbing the surface of the paper. Take your time with it; patience is a virtue in this type of work!

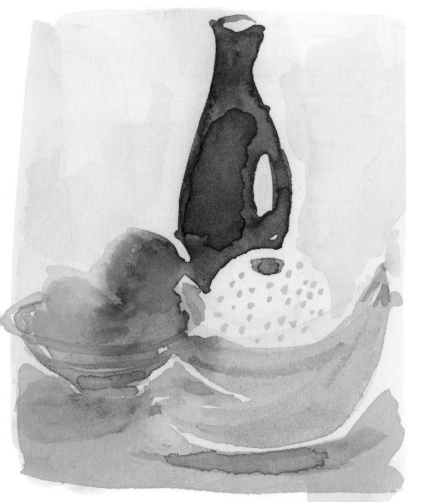

Split complementary painting: This painting is restricted to violet, and its split complementary colors: yellow-green and yellow-orange. Watercolor

Butterfly

"I wanted to mix freedom and control in this iconic painting
of a butterfly." —Greg

Resist with color partially painted

Remove resist with a rubber cement pickup

EXERCISE 5

For this exercise, we will use masking fluid, a colorless liquid that you can apply to a piece of paper. Once dry, the fluid will protect—mask—the covered areas from your watercolor paints. The masking fluid can then be removed to reveal the design it hides. Masking fluid is relatively inexpensive and can be found at most art stores. It may also be referred to as resist.

Choose a simple design, such as a butterfly or flower, and lightly pencil it onto your paper. Then, use a brush to paint the masking fluid over the lines. (The fluid will ruin your brush, so use an old one that you don't need.) Allow the fluid to dry completely so it will not mix with your paint. Once it's dry, lay down your watercolor paint. Use the watercolors loosely, allowing them to bleed into one another. The loose areas of color versus the hard line of the resist will create an interesting dynamic. Allow the paint to dry completely, then remove the resist using a rubber cement pickup, your hand, or a clean eraser. Feel free to add more paint once the resist is removed.

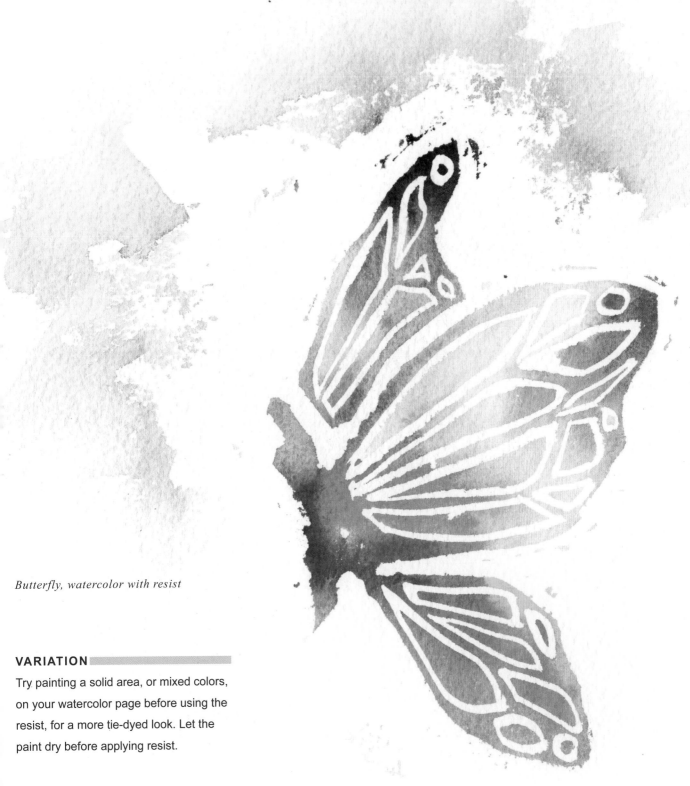

Butterfly, watercolor with resist

VARIATION

Try painting a solid area, or mixed colors, on your watercolor page before using the resist, for a more tie-dyed look. Let the paint dry before applying resist.

Layered Landscape

"I loved taking my time and seeing how colors worked in transparent layers." —Dominick

Layer 1, watercolor

Layer 2, watercolor

Layer 3, watercolor

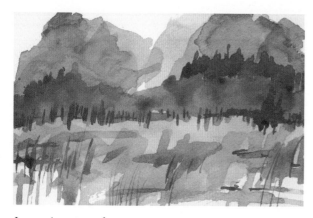

Layer 4, watercolor

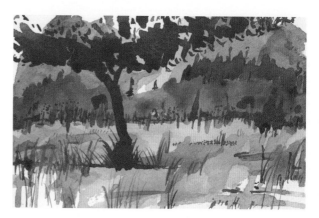

Layer 5, watercolor

EXERCISE 6

This is a meditation in color, with a luminous result. You can use this layered method, also called glazing, for many of the exercises in this book. Today, we will make it our main focus, to familiarize you with the technique.

Do this painting at a landscape location or from a photo. (A black and white photo may help you see the abstraction in the shapes.) Choose a limited palette for your first attempt: Here, Dominick has chosen a pink, crimson, and yellow range. Start with a large, multicolored shape as you see in #1, dropping the colors into a fairly wet shape to allow them to spread. Allowing the paint to dry between layers, gradually build up the picture by laying down washes of shape over previous layers, keeping each new layer of paint thin enough for transparency. Begin with more abstract shapes of the landscape; add details in subsequent layers. Working from less-saturated to more-saturated colors will give better results, but sometimes you can go the opposite way for effect. Notice how the addition of the magenta layer in #6 adds that pop of color to make the painting shine.

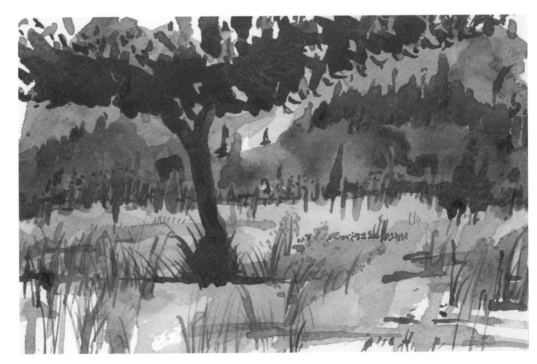

Backyard, Layer 6, watercolor

Chapter 2:
STILL LIFE AND NATURE STUDIES

Crocuses, by Dominick Santise, watercolor

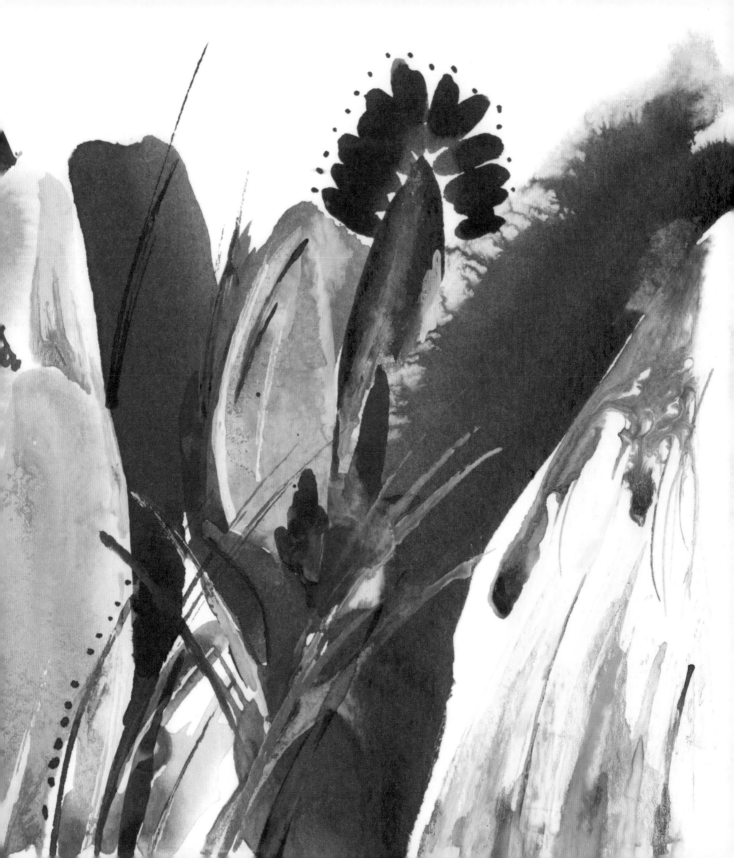

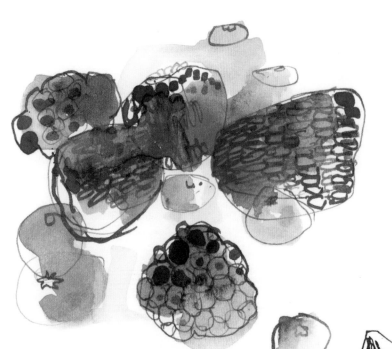

Food Studies

"Here are a few paintings from a series of food studies
I've been working on." —Greg

Berries, watercolor and ink

Peppers, watercolor and ink

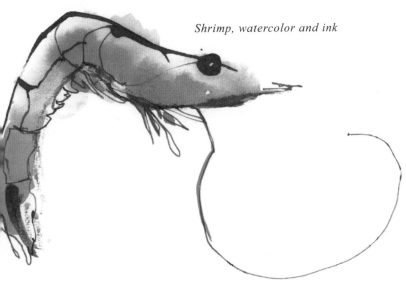

Shrimp, watercolor and ink

EXERCISE 7

This exercise is all about food—painting it, that is. Choose a selection of foods with colors that excite you. Here, Greg has painted blackberries, blueberries, peppers, and a shrimp in vibrant tones.

Start this exercise in one of two ways: Either draw a few loose shapes with a pen and waterproof ink as a rough guide, or begin without any line, by laying down some washes of color in the shapes of what you're drawing. Allow the colors to bleed into each other at times, as Greg has done, for movement. You'll have to do a little planning, thinking about where you will put the line and where you want pure color to hold the shape or information. It helps to be free about it, though, and allow things to happen with the watercolor. This is not about creating a line to fill in with color, but about finding essential form and volume.

Once the color washes are dry, use a pen and black or colored ink to draw the defining lines and some of the details. Keep the colors fairly pure and bright to create an appetizing array of paintings.

Rosemary, watercolor

VARIATION

Try painting food without any black or pencil line, as in my version of rosemary (above). Allow the initial shapes to stay a little bit wet, and drop in other colors for subtle differences, as you see done with the green and lavender.

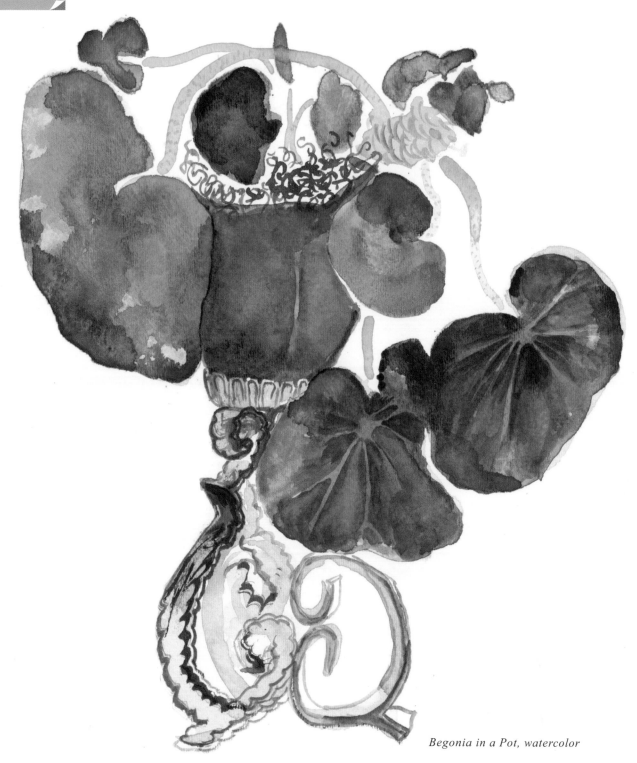

Begonia in a Pot, watercolor

Begonia in a Pot

"I decided to put my begonia plant into a decorative pot. And once I saw it in the pot, I had to paint it! I loved the way the leaves and vines felt similar to the scrollwork of the planter." —Despina

EXERCISE 8

Choose a potted plant from your home that has big leaf shapes and variations of color, like Despina's begonia. If you look closely, you'll notice the many shades of color that exist within the green leaves besides green. You may also find red tones, oranges, yellows, blues—it depends on the plant and the light.

Paint some big green leaf shapes, and while they're still wet, drip bits of the other colors into those shapes. Allow the secondary color to spread, or "bloom," into the leaf. Then add another darker layer of the green as a shape to create the veins in the leaves in the negative space. You may or may not want an ornamental planter, but once your leaves are dry, you can add a shape of color for the pot. Include some of the more subtle tones in your leaves in the pot color to create a harmonious feeling.

If you're not seeing other colors besides green while doing this, choose some other color that works for you based on your taste. The more you practice looking, the better your sense of color will become. If you have no houseplants, visit a friend with a green thumb for this exercise.

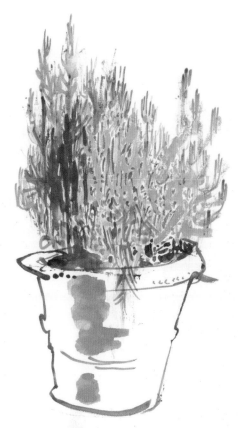

Lavender Plant, watercolor

VARIATION

For a little variety, do another still-life painting of a plant with small or narrow leaves. You can paint the individual leaves with different colors that mix with green, as you see in the lavender plant (above).

Bird in Nature

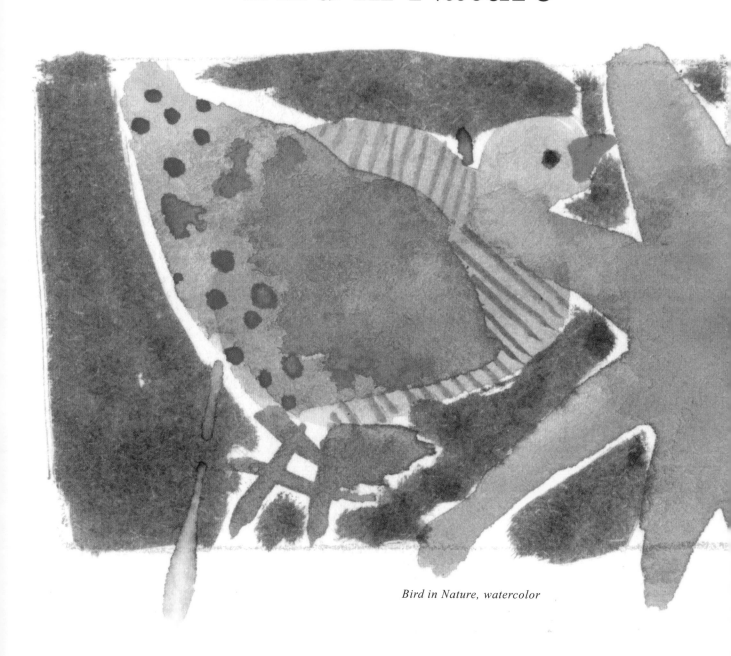

Bird in Nature, watercolor

"We New Yorkers often think we're so much 'in control.' Yet this week, Mother Nature really let us know who's in charge by sending a tornado to the city! Still stunned by how many trees we lost in our neighborhood, I spent a few minutes in my yard wondering how the birds reacted to the loss. To my surprise, as I looked, there were several out there that I had never seen before. There was this gorgeous Northern Cardinal sitting in the bushes, and a pretty busy little hummingbird, too. It's probably safe to assume they're checking out the real estate for a new place to call home." —Michele

EXERCISE 9

Go into your yard or a local park, and spend some time just looking. Take your time, walk around, be patient with yourself. Find one small thing that impresses you with its beauty, intricacy, texture, and so forth, and make a simple study painting of it. You might even do a few based on a single subject.

Sometimes even artists forget to stop and *l-o-o-k*. It's the only way to see the beauty in the world around us.

Leaf, watercolor by Despina

VARIATION

A fallen leaf can make a great subject to paint, as Despina realized when making the lovely study above. Check out the little red worm!

Toys

"There's something special about my children's toys. So sweet, just like the kids. Thought it would be nice to make a painting to remember this time in their lives. And also of my wife and I." —Eddie

EXERCISE 10

Sometimes the everyday things around us can make the most personal and inspired still-life paintings. If you have children in your home, you might try a still life by arranging some of their things in a spot that gets some natural light, and make a painting. Pencil in a few shapes to start if going straight to paint seems too difficult. Then, layer the colors in softly, lighter ones first, adding darker tones gradually to build up a soft atmospheric feel. Allow the paint to dry somewhat between layers. Once the main shapes are painted, use a thin brush with some dry paint to add details, such as the stripes on the teddy bear's shirt or his black eyes. The painting will be a nice token of this memory, long after the toys have fallen apart from too much kid love!

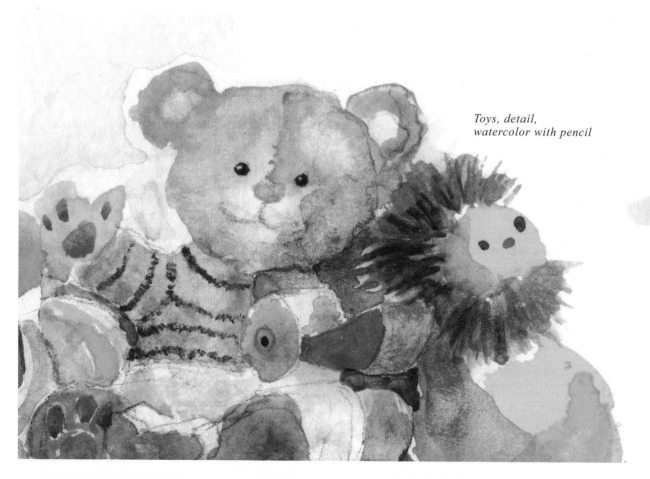

Toys, detail, watercolor with pencil

If you don't live in a house with children, select a group of very domestic items, and create a still life from that. The seemingly mundane can often create beautiful art.

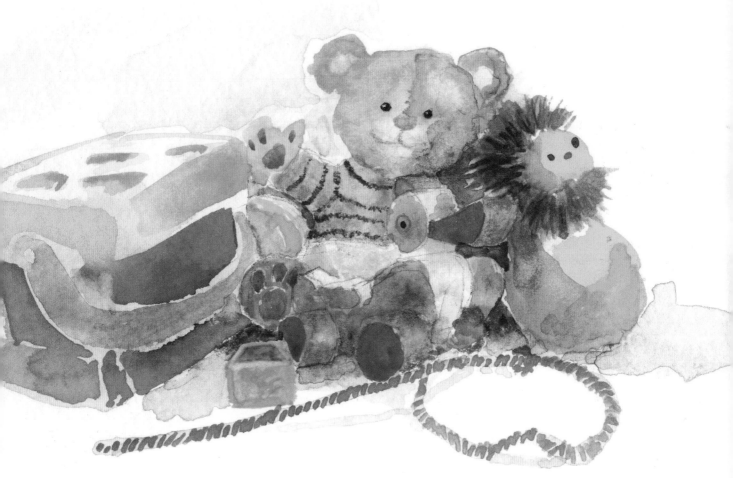

Toys, watercolor with pencil

Flowers

"I went to the New York Botanical Gardens, and I was walking by the perennial gardens. I saw so many beautiful and fully blossomed flowers. I stopped for a few minutes to paint, and I didn't get up for a few hours! They were so beautiful!" —Margaret

Flowers, watercolor with Caran d'Ache crayon and colored pencil

EXERCISE 11

Today's exercise is about painting beautiful flowers. Either from nature, in a park, or cut in a vase, find some flower blossoms that have colors you're dying to paint. Work a few shades of various colors—a grouping of reds, pinks, and oranges, for example, and then add the complement. In this case, Margaret has worked with reds and pinks, with blues and greens for contrast.

Paint each petal one by one, and let them dry. Once they are dry, you can add a bit of line with your Caran d'Ache crayons and put a background color down to complete the picture. Pencil in a rough shape of the flowers first if it helps, and use a colored pencil to draw some details once the paint is dry.

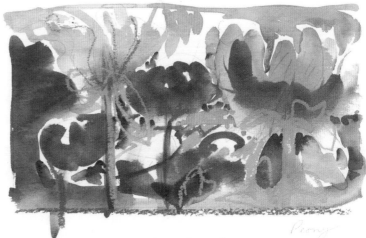

Pink Flowers One, watercolor and pencil

TIP

Try to keep the petal shapes from touching each other too much, or they will bleed together, and you will lose the overall shape of the flower. You could also try putting a full flower shape down first in a lighter tone, and then adding petal shapes over that once it's dry. You can see that technique used in Marg's smaller paintings at right.

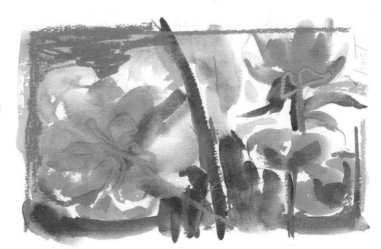

Pink Flowers Two, watercolor and pencil

Chapter 3:
LANDSCAPES

Central Park Trees, by Greg Betza, watercolor

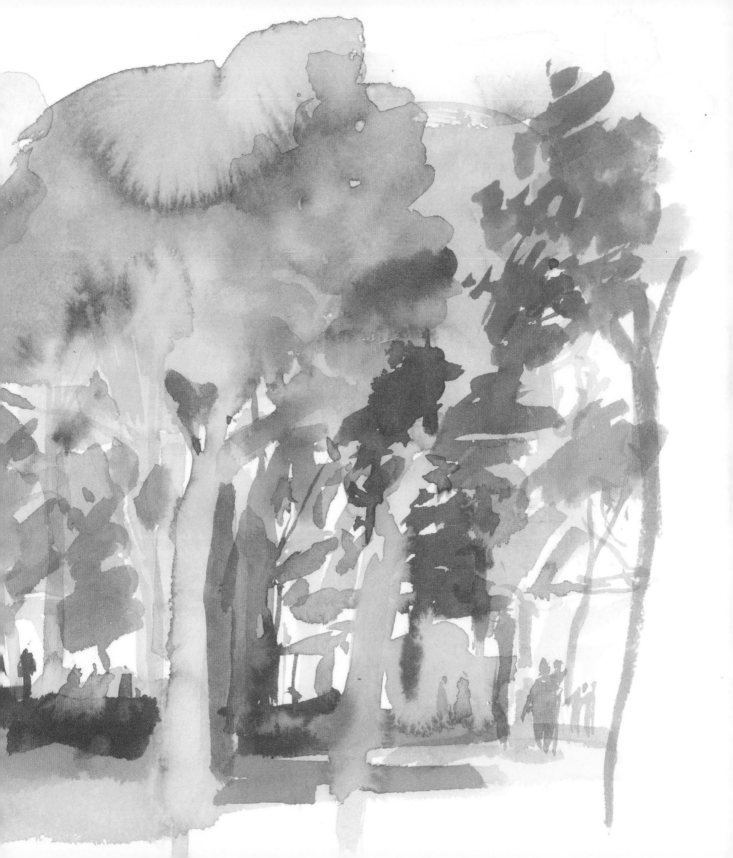

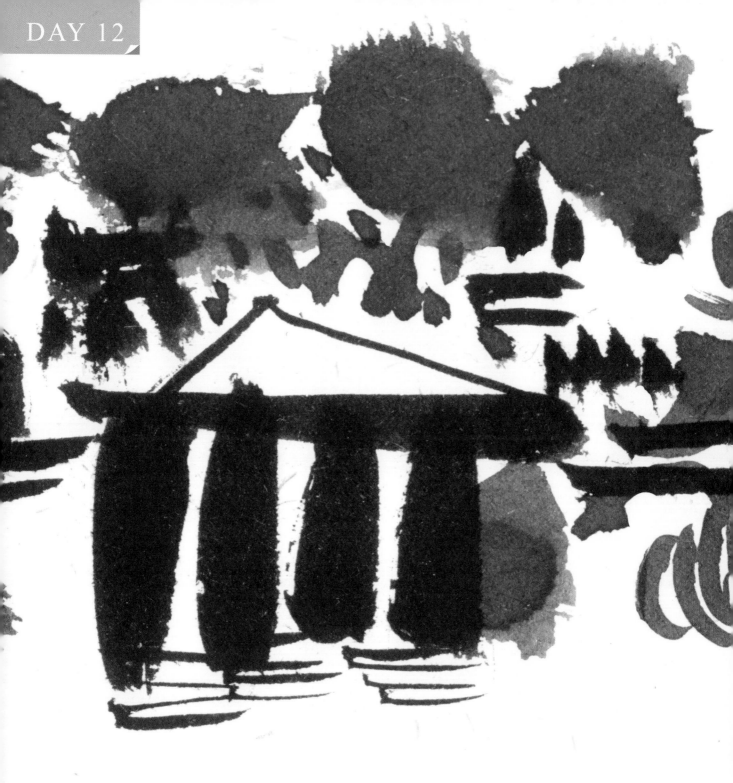

Athens, detail, ink and watercolor

Athens

"One of the wonderful things about being an American born to Greek parents is that my childhood is full of lovely memories of trips to Greece to visit family. Trips that I continue to take as an adult. One of the less-wonderful things is that with so much family to visit, there isn't always as much time to paint as I'd like. I was really happy with this simple landscape painting I did on location in Athens. I only had a few minutes, so I used a minimal color palette and bold, expressive strokes. Captures the feeling I wanted very well, even if I do say so myself!" —Despina

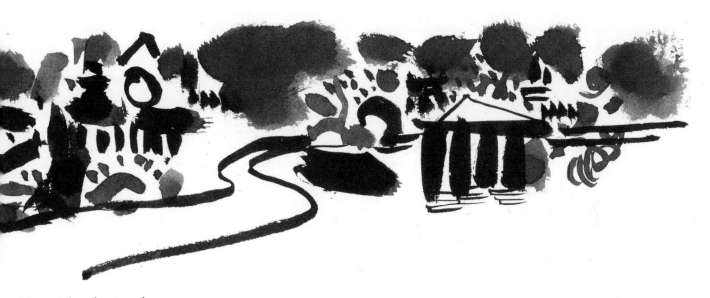

Athens, ink and watercolor

TIP

Keep the drawing/painting fairly small, to emphasize the brushstrokes. The actual size of this painting is only 2-inches (5 cm) high!

EXERCISE 12

This is a landscape on the go—choose a spot you'd like to paint, and give yourself no more than 15 minutes to finish the exercise. Select a color palette that makes sense, and ignore details in favor of large shapes, to create a landscape with bold strokes. Pick out important information that can identify the scene: a specific tree or architectural structure, for example. You might even do this from the passenger seat of a car while a friend drives! This is a mix between painting and calligraphy and a good way to start our landscape chapter.

From the Windows

"From the windows of the train, I spotted this bright patch of golden trees." —Dominick

Golden Trees, watercolor and ink

EXERCISE 13

This is a memory painting. In your mind's eye, think of a scene in nature that left an impression of strong color with you. A beautiful sunset at the beach, a blooming rose bush, a gorgeous bird flying through the trees, whatever strikes you. For Dominick, it was the view of the changing seasons in upstate New York, seen through a train window.

Once you have the scene in your mind, create an expressionistic painting of it. Expressionism is more involved with feeling and sensation than actual realism, so allow yourself to let go of the attempts to create a photo-related type of rendering. Try to re-create the sensation of the colors rather than the colors as they actually appeared.

You'll notice that Dom has created the basic tree shapes with bright colors, allowed them to dry, and then added other marks and texture with Caran d'Ache crayon, a little bit of ink, and his fingerprints.

Golden Trees, detail, watercolor with fingerprint marks

TIP

Try adding your fingerprints for some interesting texture in the painting. Besides that, you can also try scratching into it, pressing twigs or leaves into it; anything that will aggravate the surface can create an interesting tactile experience.

Happy Spring

"I made this painting in the Japanese pavilion at Epcot.
It expresses the feeling I feel when spring finally arrives."
—Veronica

EXERCISE 14

Go to a garden, preferably one that is a little wild or overgrown, and find a nice comfortable spot. With a light pencil, block in some simple shapes of what you see. Once you have those shapes blocked in, it's time to start painting.

Lay down the color in large areas, using the shapes you drew as a rough guide. You want to fill every shape with color—we won't be doing much layering in this one—and don't stress out if the colors occasionally bleed from one shape area into another. Accidents such as that work for the expressionistic aesthetic we are playing with here. In that same vein, be free with your color choices. Let your personal taste in color dominate.

You'll notice in the painting that after the main color forms dried, I went back in and added a few hints of detail such as leaves and branches in the trees. I also added a few shapes to describe the fence in blue. Adding a few darker shapes on top of the base colors will add depth to your painting.

Preliminary drawing, pencil on paper

TIPS

- When you make the initial drawing, keep it very light and underdeveloped, as I've done in the example at left. You don't want a lot of detail interfering with the spirit of the painting.
- To increase the amount of pigment on your brush, it's helpful to use a spray bottle to wet down your watercolor pans or tube paint palette before beginning, and let it soak a little.

*Japanese Garden, pencil and
watercolor on paper*

Versailles

"I've always loved working with watercolor. Here is a reportage painting made while sitting in the gardens at the Palace of Versailles in France. It's an amazing place." —Greg

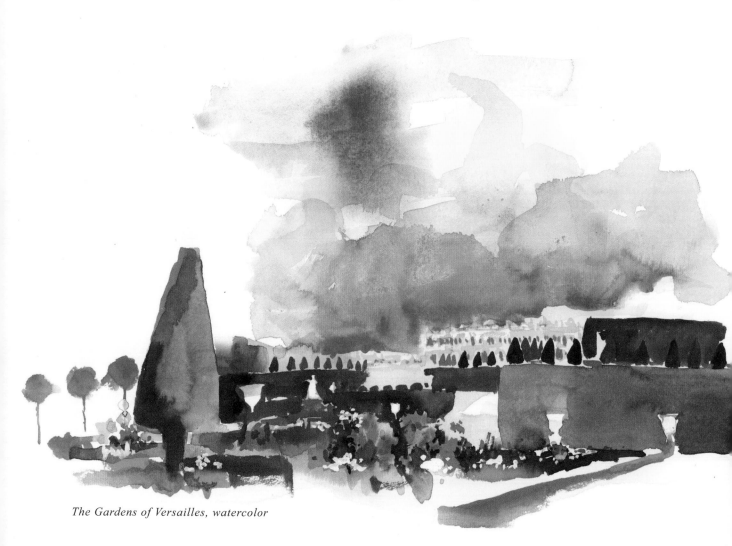

The Gardens of Versailles, watercolor

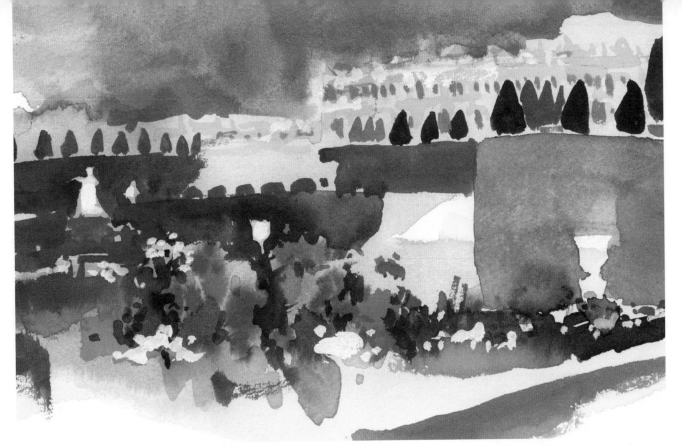

The Gardens of Versailles,
detail, watercolor

EXERCISE 15

Go to a formal landscape, and set yourself up to create a plein-air painting such as Greg has done. It needn't be the garden at Versailles, although of course, that *does* sound good, but can be any garden with manicured trees and bushes. These can often be found at hotels, or sometimes even at the home of a friend! (I'm sure your friend would appreciate a beautiful watercolor of his or her landscaping efforts.)

Lay down your color in very pure form, from light to dark. You can see that Greg has painted in the yellows, then greens, and then browns and reds. He has also used a little bit of white semiopaque watercolor to pick out some highlights. Keep the shapes geometric for this exercise, even if you exaggerate what's actually there.

TIPS

Try not to rush your color layering. A nice sunny day is probably the best day to choose for this exercise.

Laying down a light color in a broad area helps to set the color tone for the entire painting and will pull all of the other colors together. In this painting, Greg has used yellow in a very predominant way as his underpainting.

In Love with Swans

"I followed a few swans for a few weeks and made a series of watercolor/ink studies. I love the gracefulness of them, so beautiful." —Margaret

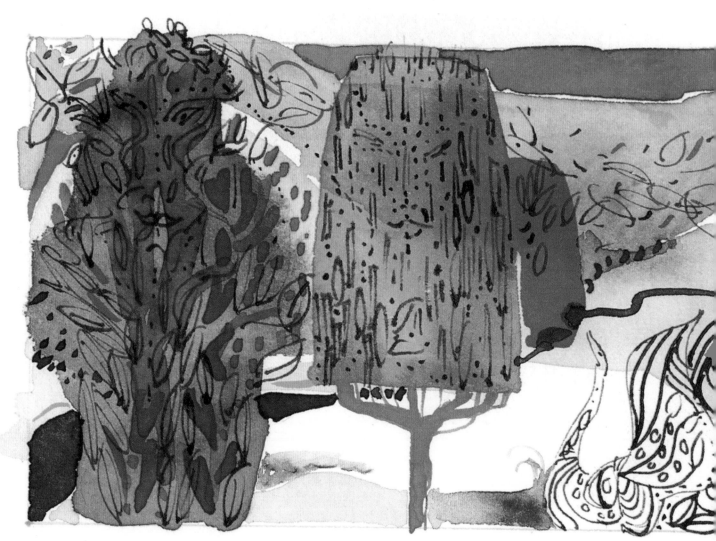

Swan and Trees, watercolor with ink and gouache

EXERCISE 16

Go to a garden, and bird watch. (You might even go back to the garden you were at for yesterday's exercise.) But while you watch, paint. Try getting very decorative as Margaret has done here, to create a fantasy-like feeling with your paintings.

Try several different things in small thumbnails—these paintings are only about three inches (7.5 cm) wide! The smaller size will allow you to do more of them in a day, trying more variations. Every one of these paintings starts with a large shape or several large shapes. Do the same, preparing two or three simultaneously. Allow the painted shapes on them to dry, and then add details and marks on top of the shapes in both watercolor line (with a thin brush) and ink. Try making marks for leaves or flower petals. Notice the way Margaret keeps the swan consistent as an ink drawing in these paintings, which holds it together as a series. The birds also add a nice sense of movement.

If there are no birds to draw, you can make this small series of decorative fantasy landscapes without them. Try picking out a different element to keep consistent: a flower, a particular plant, or a manmade object in the landscape.

TIP

Vary between wet and dry painting to achieve the different kinds of sensations with color and line you see here. A shape of solid color, applied very thickly, will hold up well against an area of loosely applied varied color applied in a thinner wash.

Swan Miniature Paintings, watercolor with ink and gouache

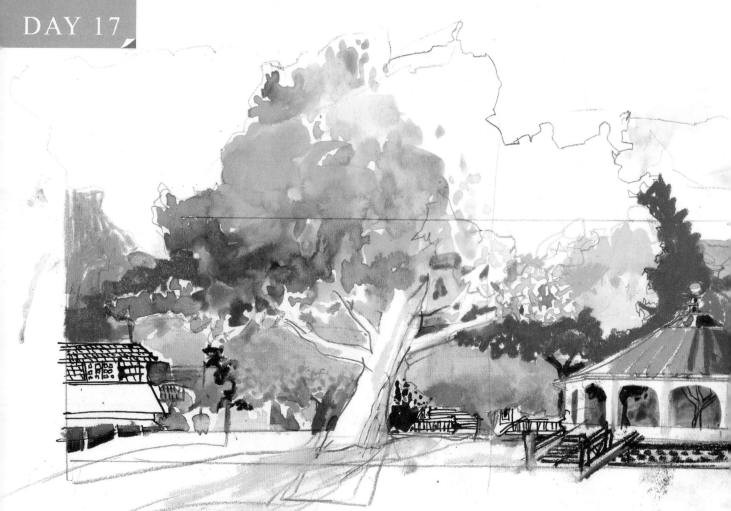

Mystic Seaport

"Mystic Seaport in Connecticut is like a village sitting in time, just waiting to be painted. I love the authenticity of the old seaport village and the genuine good character of the people who work there. On a crisp fall day, the place can't be beat."
—Eddie

EXERCISE 17

Today's exercise is a panoramic. This is your chance to create a large-scale painting of a place you love. Eddie has chosen Mystic Seaport in Connecticut, but any place you love to spend time in will work. Go for a place with a mixture of buildings and nature, so you have a lot of detail and information to play around with.

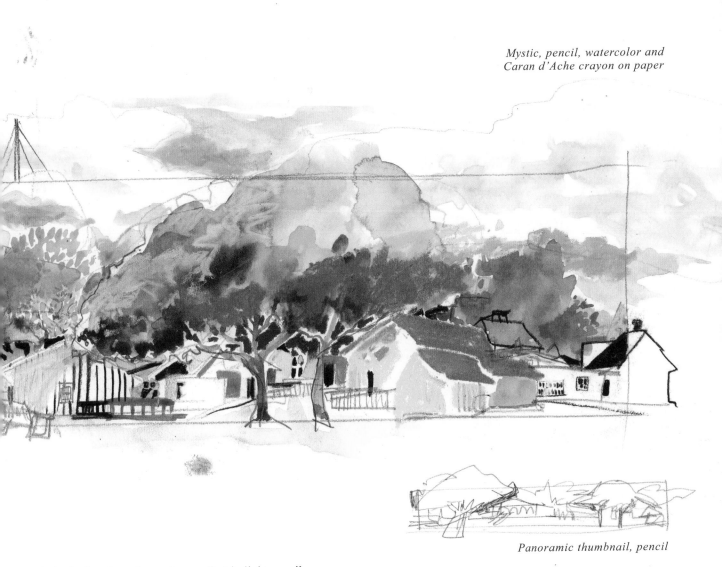

Mystic, pencil, watercolor and Caran d'Ache crayon on paper

Panoramic thumbnail, pencil

Begin by laying down large shapes, first in light pencil outline, and then in blocks of color. Working from the lighter colors to the darker ones, continue to layer areas of paint over the original shapes, first allowing the initial shapes to dry. Then use Caran d'Ache watercolor crayons or a small brush with drier watercolor pigment on it to add some details such as leaves and bricks. Don't be afraid to leave some white space, as Eddie has done, to keep things lively.

TIP

Before you begin your large panoramic, it would be a good idea to make several little thumbnail drawings, like Eddie's, above, to get a sense of big shapes, and lights and darks in your painting.

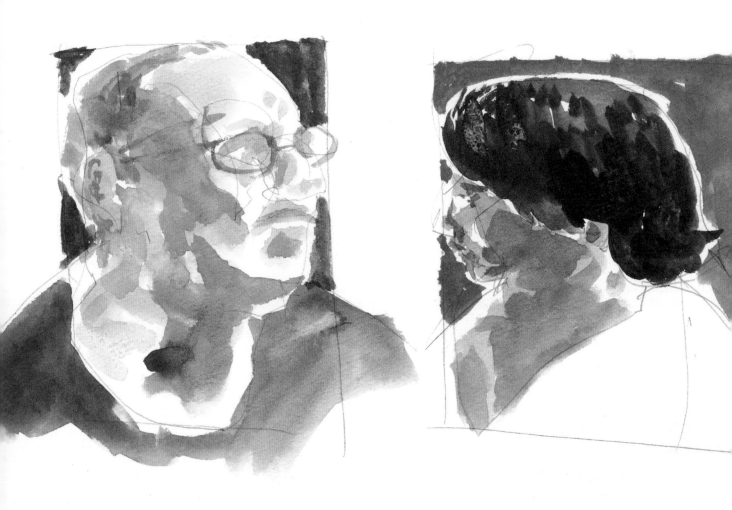

Chapter 4:
PEOPLE

Portraits, by Eddie Peña, watercolor and pencil

Workout

"I recently tried Pilates—almost threw my back out! But it was fun to be at the gym, painting all the people doing their various exercises. That's a workout I like!" —Margaret

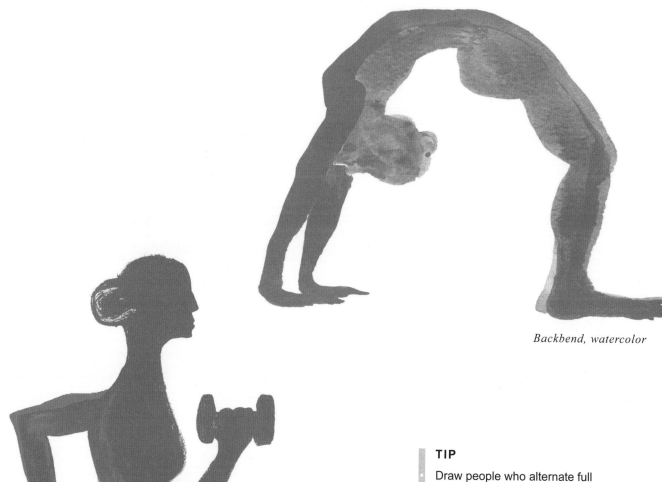

Backbend, watercolor

Weightlifting, watercolor

TIP

Draw people who alternate full movement with still positions, such as people doing yoga, if you have never tried this kind of thing. It will give you both movement and a few seconds of stillness to really study the figure.

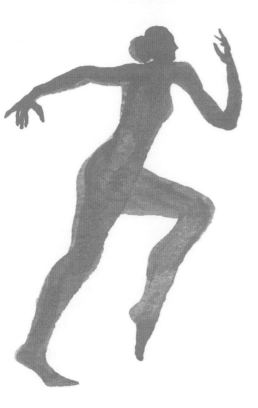

Running, watercolor

EXERCISE 18

Choose just one color, and use it to create silhouettes of
people in motion. A gym would be a great place to do this;
so would a dance class. A group of children playing could
work, too.

Look at the shapes of the figure—obviously if people are
moving, it's not the easiest thing to get down on paper, so
trust your memory, and keep painting the shape even after the
person has moved to another position. This is great practice.
Don't judge your early efforts too much; visual memory is
something that gets developed over time. Just doing it is the
most important thing.

Jogging, watercolor

Bowling

"Okay, I've discovered that I am kind of terrible at bowling. Here's a look at the difference between how I bowl and how my good friend Nadia bowls. She is so graceful and almost looks like she's dancing out there. I, on the other hand, am so uncoordinated and just . . . well . . . I look like a mess!" —Despina

RIGHT

EXERCISE 19

This is about using the flow of a brush to show movement. Go to a place where you can observe people doing some kind of repetitive movements: could be people bowling, dancing, jogging by, as long as you can see the action. While watching the people, take your brush, full of color, and *follow* their movements with your painting. You can add details such as the feet after the brushstroke dries, or simply let this be an abstract study of movement and calligraphy.

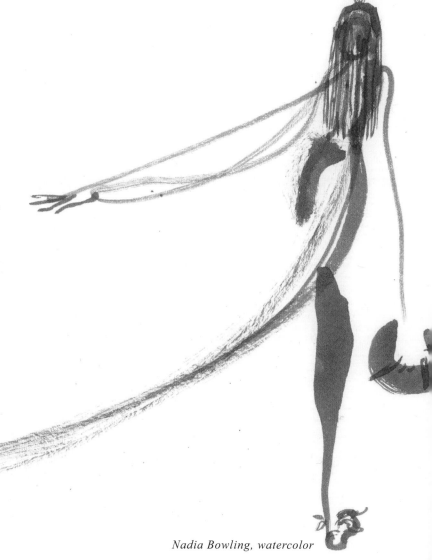

Nadia Bowling, watercolor

Notice the differences between how people move, and try to achieve those differences in your drawings. You might even assign a different color to each person, as Despina did here by making the graceful bowler blue, and assigning red to the, uh, not-so-graceful bowler. Exaggerating by using overlapping forms or distorted motion can help you emphasize the differences as well.

WRONG

Despina Bowling, watercolor

New Yorkers

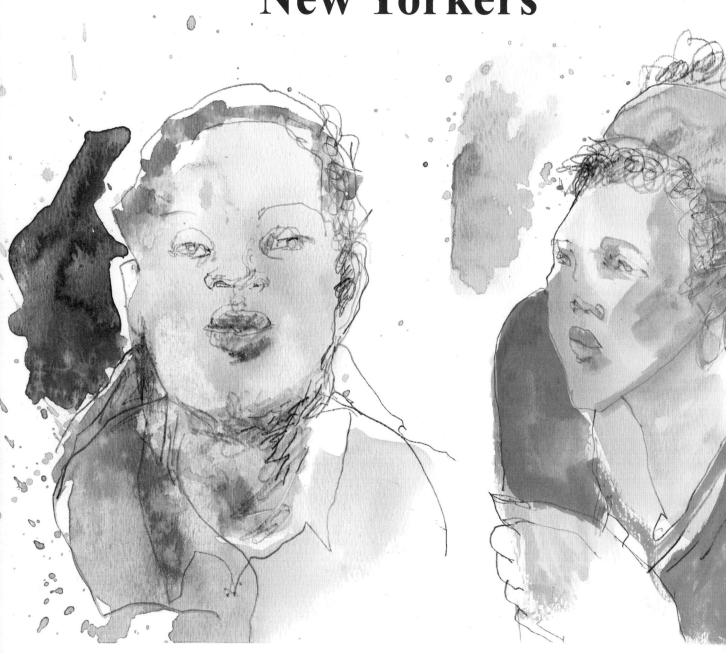

Portraits of New Yorkers, pencil and watercolor

"I love New Yorkers. The first hint of nice weather, and we are all out sunning ourselves in droves! These portraits were done on location in Central Park. It was fun to sit and play with the paint for a little while, and the people weren't moving around too much as they were basking in the sunshine." —Veronica

EXERCISE 20

Go to a place where there will be a lot of people sitting for an extended period of time, such as a park or shopping plaza. Use a graphite pencil to draw a few lines as a start for your portraits. Some simple shapes of the face will work. Try not to judge too much or worry about realism of the facial features or a likeness, but do notice how the light hitting someone's face will create an abstract shape, and try drawing that.

Once you have your light pencil rough, take your watercolors and add a few large shapes, filling the shapes you drew lightly with your pencil. Don't be too concerned about staying in the lines; it's a guide only. Let these shapes dry a bit, then add other colors on top of them. You can use the back end of your watercolor brush almost like a stick pen to add some more texture and linear color effects. Just dip it into the watercolor paint like you would into ink. Add a splatter of another color here and there, for an energetic feel, if you like. Play with different color and texture combinations to see what you can create.

Splatter: wet into wet

Splatter: wet into dry

TIP

To create the spattering effect, put a lot of pigment on your brush, and make sure it's fairly wet. Setting one hand perpendicular to the paper as a barrier, tap the watercolor brush against the edge of your hand to splatter the paint out of the brush bristles. You want to be a couple of inches (5 cm) above the painting when you do this. Control the splattering into one area, or simply let fly—it's your painting, and your decision.

Play with the differences between spattering color into a wet area of color as opposed to a dry one.

I Hate Pink . . .

"My daughter insists that I love pink. I tell her, 'I do NOT love pink.'
But she continually insists that I do. So I decided to give her some pink
in this drawing." —Dominick

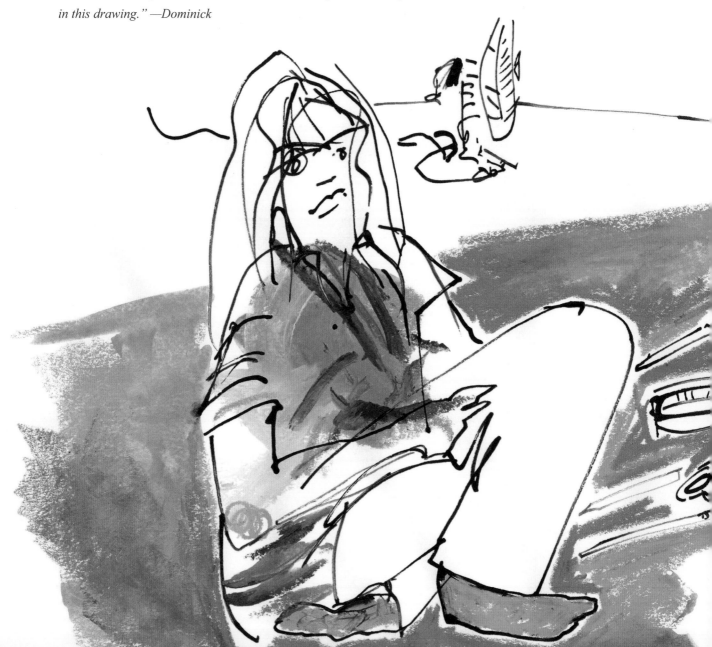

EXERCISE 21

This exercise is about creating a portrait working with a color that you absolutely HATE! We all have those colors, the ones that we just never seem to put down on the paper. Whatever that color is, seems everyone's paint box has at least one of them that never runs out: blue, yellow, brown, green, or, in Dom's case, P-I-N-K.

 Take an old photo of someone you love, and create a portrait from that photo. Start with a little pencil or pen (with waterproof ink) to get the basic drawing down. Then, use your Caran d'Ache crayon in the unpreferred color as the main tool for the picture. Mix line with shape to come up with a painted drawing that is dominated by the color you hate, adding a little water with your brush to allow a smoother color texture along with the rougher crayon one. Cheat a little like Dom, and add a second color, or be a total purist, and see how far you can push the one.

VARIATION

Of course, after working with the color that you hate the most, the only reasonable thing to do is to create another portrait using the color that you really love. Apparently, Dominick loves yellow.

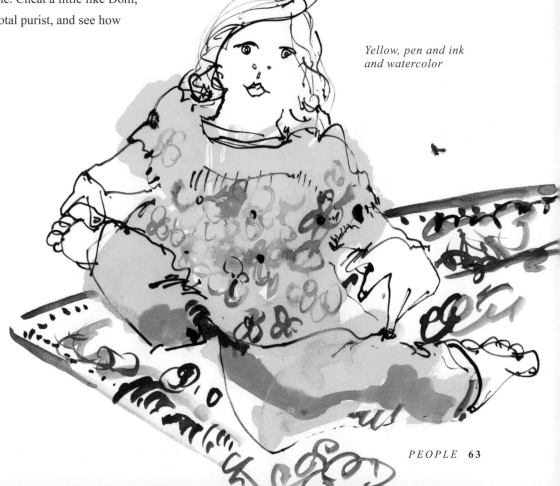

Yellow, pen and ink and watercolor

Pinkie, pen and ink and Caran d'Ache crayon

A Study on the Spot

"The experience of drawing your way through Disney World is really indescribable. This brief but intense study trip was everything I'd hoped for and more. The Magic Kingdom has always been a home away from home for me; I have learned so much there. What a pleasure to sit in the bakery on Main Street and draw this group of women enjoying the view—and the air conditioning. I combined the watercolor with charcoal to explore what might result." —Michele

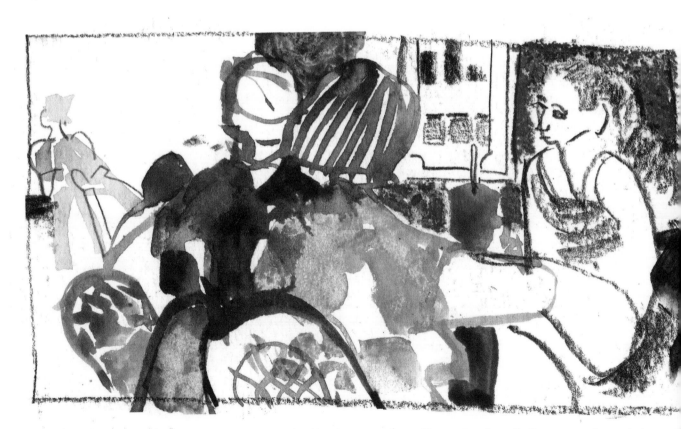

Women Drinking Coffee, watercolor and charcoal

EXERCISE 22

Try drawing directly with watercolor as both line and shape. You'll need a fine and a medium brush for this exercise. Go to a local café, and situate yourself at a table from where you can watch a group of people drinking coffee together. Using your small brush, pick up some color, and begin to draw the shapes of the people linearly. Keep the paint fairly dry, so you get a good solid line, but not so dry that you lose the transparency of the watercolor. Once you have put your lines down, use your medium-size brush to fill in the shapes you want filled. Don't worry if the colors bleed into each other a bit; that's the beauty of this technique. Try doing some of the line in charcoal as well, as Michele did.

Woman, watercolor

TIP

Before you do a full group of people, start with some single portrait studies. First try one with charcoal or graphite line and color (below right) and then do one or two with all watercolor line and shape (above right). Mix and match: When you feel comfortable with the technique, move on to a group of figures. Don't worry about likeness and realism; the point of this exercise is to play with the medium and become more comfortable drawing people on location.

Woman in Hat, watercolor and charcoal

People in Nature

"This is one of my favorite paintings. I did it on a sunny day at Disney's Animal Kingdom." —Greg

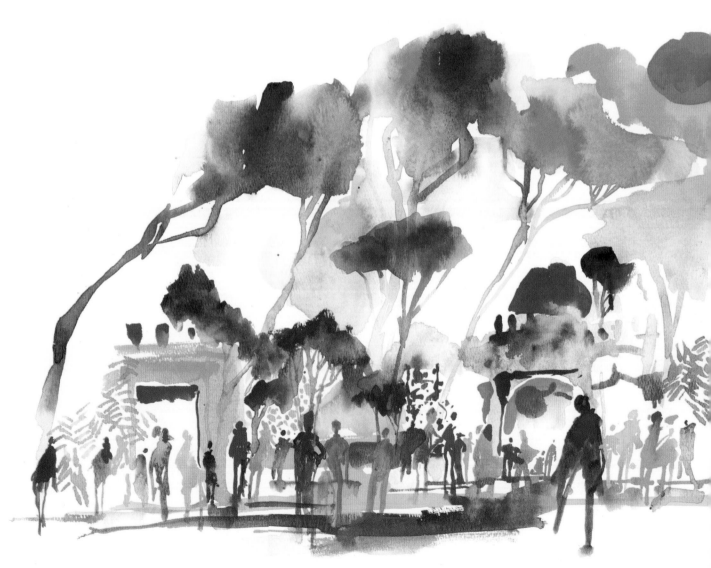

Animal Kingdom, watercolor

EXERCISE 23

Now that you've done a few exercises with people, it's time to put them into an environment. You could do this exercise just about anywhere: a zoo, a local amusement park, a public garden. Find a place where people gather that combines both architectural and natural elements.

Working fairly quickly, look at the crowd of people, and paint rough shapes for each person in various colors.* Any color is fine; realism is not necessary here. Don't allow the paint to get too wet; there will be a lot of elements in this picture, and you don't want them to bleed into each other too much. Once the people have dried, add some background elements such as building shapes, shrubbery, and trees. Begin with larger shapes, adding details such as leaves and marks after those shapes have dried.

You might paint one large overall shape before you put anything else in the piece; look at how Greg painted the large yellow shape of the left-hand building and the ground, and built the other people and elements on top of that. Having one larger shape in a color helps keep the picture together. He then brought the yellow in again with the tree at far right, to keep a balance that made sense to his eyes.

TIP

Choose a small range of colors to identify the different shapes of the people. Don't keep the colored shapes in their own section of the painting; instead, mix them across the picture, similar to the way Greg has done here. This will keep harmony in the painting.

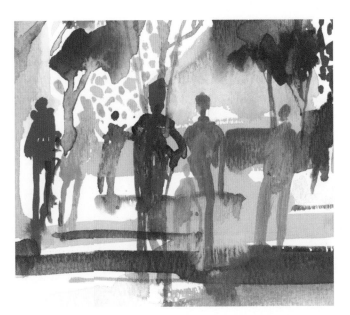

Animal Kingdom, detail, watercolor

Chapter 5:
PATTERNS AND DIGITAL WORK

Turks & Caicos, by Veronica Lawlor,
watercolor, pastel, and colored pencil

Playing with Patterns

"I enjoy studying patterns; these are from hundreds of experimental
pattern plays." —Eddie

African-inspired, watercolor

EXERCISE 24

Paint an element in one color and its different values. To create a tint of a color, you can add a little white. To create a shade of that color, add some black. Adding a little of the complementary color will give you a graying-down effect.

Create a square pattern, and then "tile" it, which means to repeat it in some way. For this exercise, let's do a simple repeat: Flip it horizontally across, and then copy and flip those two squares vertically down. If you look at Eddie's example (left), you'll see how one element has been manipulated to create a pattern.

You can do this digitally in Photoshop or Illustrator, depending on your computer skills. If you choose to do the entire exercise by hand, a piece of vellum, a translucent paper sturdier than tracing paper, can be used to flip the image and trace it several times. Paint it once you've got it all drawn out.

Anything can be used for your initial design for the repeat. Here, Eddie has taken inspiration from African textiles. You can use anything: cultural elements, familiar elements such as fruits and flowers, or something personal to you.

TIP

Think about how the ends of your initial design will come together as a pattern. You might do some pencil sketches before you do any painting to be sure you like the way your element is joining once it is tiled.

Single element, four times, watercolor

Single element tiled, watercolor

Inspirational Experiment

*Cultural Patterns,
watercolor on paper with
white gouache and
metallic gold marker*

*"This is a series of watercolor and gold pen pattern designs that I created. I
had been looking at a lot of Japanese fabrics and prints, and they inspired
me to paint, draw, and design these 'patterns of nature.' They were an
experiment in abstraction, pattern, and design, and I ended up really
enjoying the process and the end result." —Margaret*

EXERCISE 25

Choose a culture that inspires you visually, and do a little research into the traditional textiles typical of that culture. In this case, Margaret used Japanese kimono print designs, but you could use Indonesian textiles, Peruvian weaving, anything that appeals to you. Choose a few elements of the textile print—a shape, mark, or decorative element. Then pick a limited color palette inspired by the textile you're looking at. Create small thumbnails as Marg has done, mixing these elements to come up with something new.

If you are not close to a museum that displays textiles, your local library or bookstore will have books that you can work from. Try not to be too focused on results; just play around and see what comes up. It's a beautiful way to appreciate other cultures.

Cultural Patterns, detail

TIPS

When working with multiple colors and layers like this, it's a good idea to put down lighter or less-saturated colors first, and let them dry. Then add your darker colors and details over that, keeping the brush pretty dry. A thin brush will help you to create the linear effects you see here, and a small amount of white gouache can be mixed into any color for a little more opacity in the decorative accents. The gold line you see in Margaret's work was made with a gold paint marker, available at most art supply stores.

Patterns Inspire

"These are from a series of watercolors I did years ago in the Japanese gardens at Epcot. Then influenced by the patterns presented in traditional Japanese kimono designs, it was hard for me to resist exploring what can happen when the natural patterns a garden makes and the theatrical patterns kimono-clad women make merge together." —Michele

EXERCISE 26

Visit a manicured-style garden, and make some studies of the shapes and patterns you'll find in the landscape. A local botanical garden or green public area would be perfect. Notice shapes of shrubbery and trees, and how leaves, twigs, and rocks create patterns within those shapes.

Include figures walking by as shapes in your study, or add them with the help of a photo at home. Combine these paintings with your pattern experiment from Exercise 25, putting your own designed patterns on the figures you've observed. Using kimonos or robes is fine.

This is an advanced exercise. If you are a beginner, I would recommend starting with one figure and a simple garden background.

> **TIP**
>
> Choose colors for your pattern that will stand out against the colors of the garden, as Michele has done with the red kimono against the green (above).

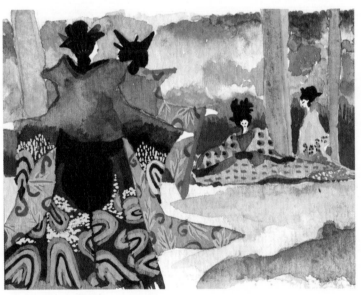

Japanese Ladies, watercolor

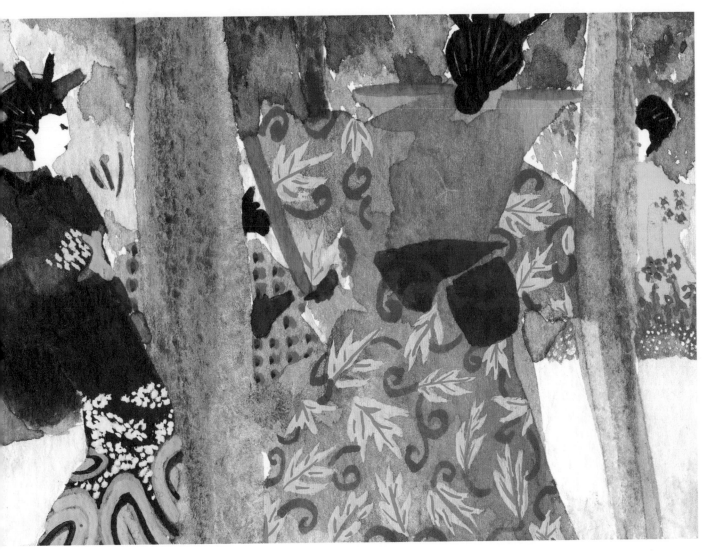

Japanese Ladies 2, watercolor

Decorative Textiles

"While creating illustrations for the Cinderella story, I got really involved with eighteenth-century European textiles." —Veronica

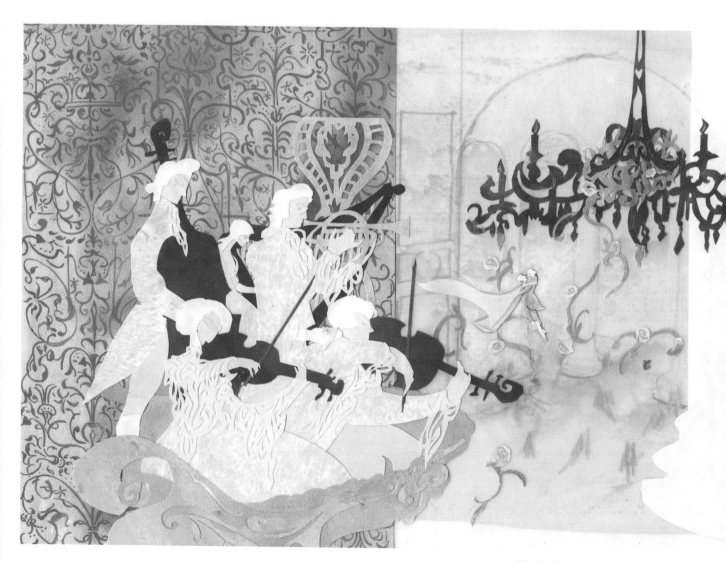

Cinderella at the Ball, watercolor and gouache, with pencil and cut paper

EXERCISE 27

Create several colored papers for use in a decorative picture you would like to make. It doesn't have to be a fantasy like my Cinderella at the ball illustration; it could be another version of one of the still-life pictures you did earlier in the book, or maybe a painting of holiday symbols for a handmade card.

Use your watercolors to paint on various sheets of paper. Apply the wet paint in a fairly loose style, and try dripping other colors in for a varied look to the color. You could paint analogous colors together, mix primaries, and so forth. Play a little. Once the pages have dried, copy some eighteenth-century European patterns on top, for a textile look. Use your gouache and a small brush for this, so that the designs will be opaque on top of the watercolor sheet. Once the pages are dry, cut shapes out of them and assemble them for your picture. (I would use fairly thin watercolor paper for this exercise.)

You can find many old European patterns online, or get a book from your local library or bookstore.

> **TIP**
> Henri Matisse famously created cut paper paintings at the end of his life; you might look them up for some inspiration.

Cinderella at the Ball, detail, watercolor and gouache

Michele's Garden

"Here is a small drawing I made in my garden, inspired by Marc Chagall. Thought it would be fun to do. If you look closely, you'll see I used watercolors, colored pencil, and a digital pencil. I invite you to try it; it's one of those things you can just feel your way through. Would love to see your version some time!" —Michele

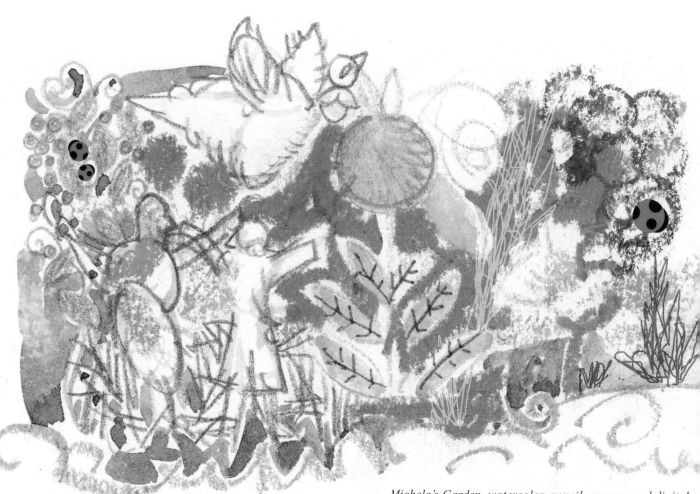

Michele's Garden, watercolor, pencil, crayon, and digital

EXERCISE 28

Create a painting to show the universe in your own garden!
First, paint a very loose background of color. The base of the
painting at left is simply yellow and green color allowed to
mix in the center. Once the paint dries, use colored pencil and
crayon to draw leaves, flowers, etc. Next, scan the art and use
a digital drawing tool, or the mouse, to create finer line draw-
ings of of leaves and flowers on top. The ladybugs were drawn
with a digital black line and filled in with red, using the paint
bucket tool. Play around to see what effects you get. If you
don't have access to a computer, create the painting for this
exercise with watercolor, colored pencils, and gouache.

TIPS

Plan out the painting before you begin, by making a small
color study. This way, you'll know ahead of time what parts
of the painting you want to create digitally, and plan your
watercolor shapes to work with that.

The eraser tool in Photoshop set to a very thin width can
be used to create a drop-out line, as in the white grass
shown in the detail at right.

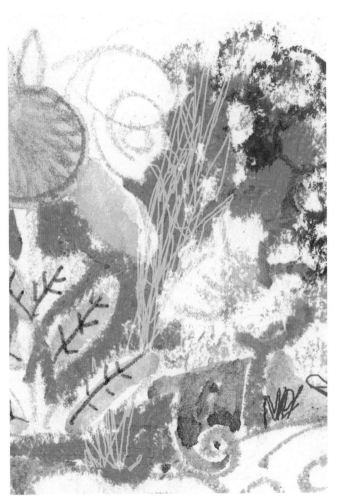

*Michele's Garden, detail, watercolor,
pencil, crayon, and digital*

iPad Paintings

"I've been experimenting with 'watercolor' paintings on the iPad. It's a lot less messy for sure, and it's interesting for me to get to know a new medium.

Did a still life, and some fruits and vegetables to start, and then went over to the Turtle Back Zoo and decided to paint a few birds. I couldn't help but paint the ostrich in a comical way—they are so goofy looking!

I'm thinking I can use this new app for all kinds of illustrations; it's really a lot of fun!" —Despina

Ostrich, digital painting

TIP

Digital applications produce lower-resolution images than you can get by scanning original art. Keep that in mind when using them.

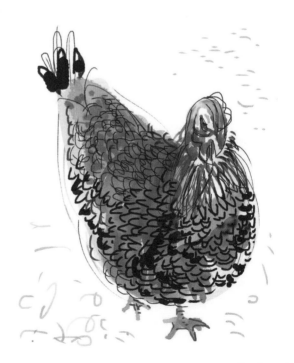

Chicken, digital painting

EXERCISE 29

Use your iPad with the Auryn Ink app to paint some digital watercolor paintings. Keep it simple at first; you could do a few fruits and vegetables around the house, or go to the zoo and paint some animals, as Despina did here.

Notice the way she layered the color in the animal paintings, putting big descriptive shapes down for their bodies, and then using a "dry" brush to add marks for the feathers and other details.

If you don't have access to an iPad or iPhone, you could go to the zoo and make some traditional watercolor paintings of the animals using a similar approach.

Red Pear, digital painting

Still Life, digital painting

Purple Avocado, digital painting

Orange Fennel, digital painting

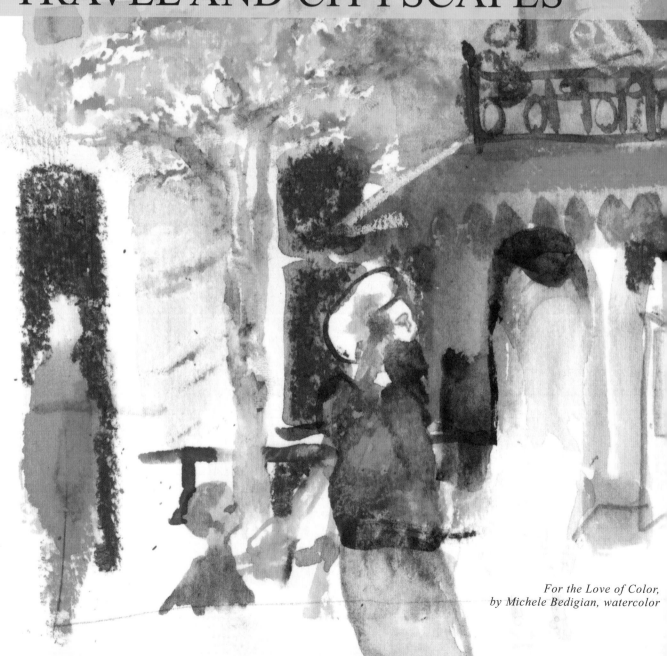

Chapter 6:
TRAVEL AND CITYSCAPES

For the Love of Color,
by Michele Bedigian, watercolor

Eiffel Tower

*"Somehow, I often find myself thinking of Paris.
Which of course, leads me to think of the Eiffel Tower.
Beautiful." —Dominick*

*Eiffel Tower,
watercolor*

EXERCISE 30

Create a symbolic icon using shape and color. You might visit a landmark of your town or city, or work off a photograph of the landmark of a place you would like to visit one day.

Look for the main structure of the icon. In the painting at left, Dominick has reduced the amount of detail in the Eiffel Tower, choosing to focus on the main shape and the height. Any color is fine: The bolder, the better!

VARIATION

After you've done a singular kind of structure such as the Eiffel Tower, you might want to create an iconic scene, as Margaret has done with her painting of Venice (right). Notice how she uses big shapes and bright colors, even to describe the gondolier!

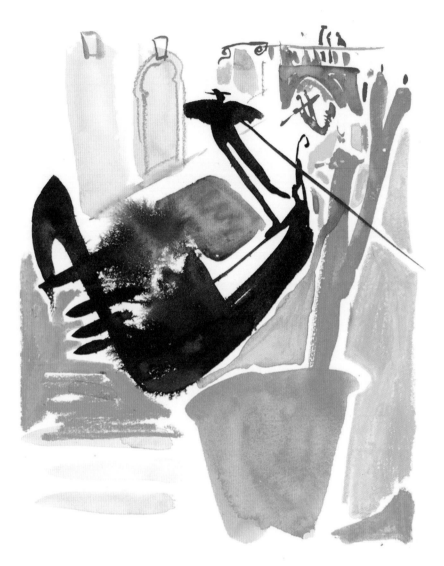

Venetian Canal, watercolor and Caran d'Ache crayon

Bronx Rooftops

"The view from my rooftop in the Bronx, New York, a.k.a. the BX—home sweet home." —Eddie

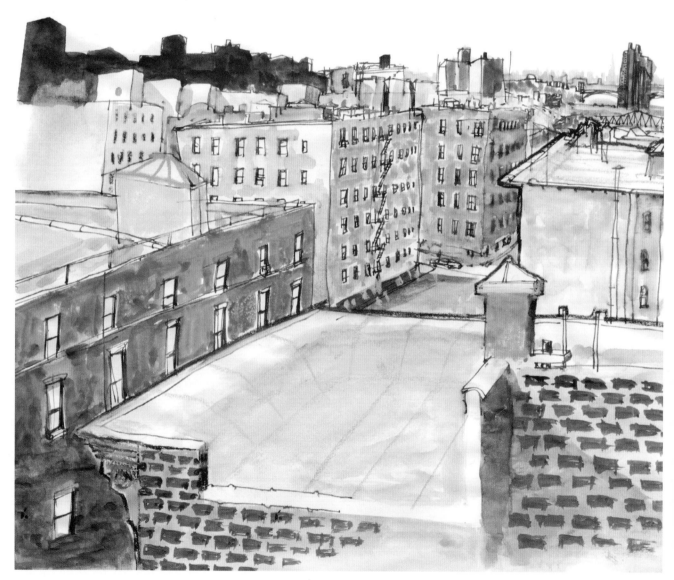

Bronx Rooftops, ink and watercolor

EXERCISE 31

Line and color: a beautiful combination! For this exercise, you'll need a dip pen and waterproof black ink or a waterproof razor-point pen, plus your watercolors, of course. Get to a high place in an urban or town setting: a rooftop, a restaurant or café on a high floor with windows, a bridge, and so on. (If you live in a more rural setting without access to a cityscape, you could do this exercise by working with an aerial photograph of an urban area.)

Using black line, make a drawing of the view before you. Add as much or as little detail as you want, but do include a few details such as windows, as Eddie has done. Leave some areas open to add detail later with watercolor. Once the

drawing has dried, use your paints to fill in the color, almost like a coloring book. Definitely play with the amount of colors you put down, and vary the concentration of the pigment, so you'll have a range of hues and values. Once the paint has dried, add some color details, like the bricks at left, using your paint in a much drier state. Darker details over lighter colors work best; if you want to put a light-colored detail over a darker area, switch to your gouache medium, which is more opaque.

VARIATION

Once you do a painting where the color dominates the line, you might try one where the line is more dominant, as in this picture of urban handball players I did in New York's East Village. You might try nonwaterproof ink in this one, to see what it does.

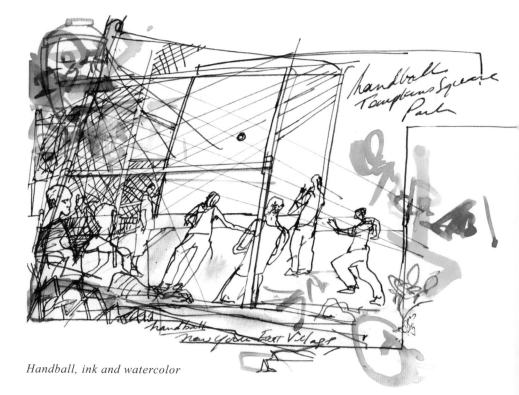

Handball, ink and watercolor

Xydas River

"I painted this during an amazing trip to Greece. My family and I visited Crete, Santorini, and Athens, and we were fortunate to have ample time to create some art. This painting is of the River Xydas, in the village of Kalyves on the island of Crete. The three boats have become somewhat of an attraction for the village. They are a reminder of how vital fishing was to Kalyves." —Greg

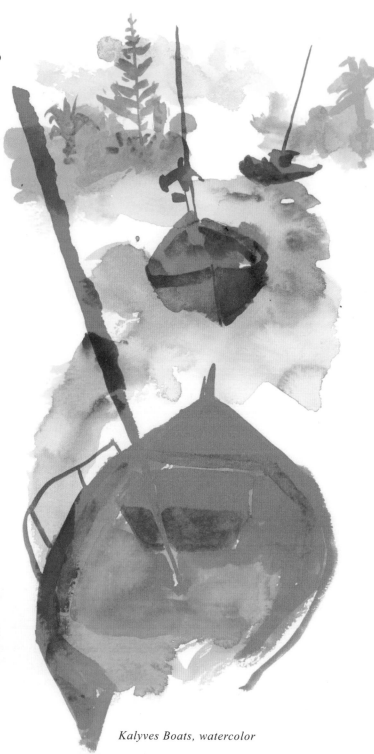

Kalyves Boats, watercolor

EXERCISE 32

Today, we are going to play with transparencies in watercolor, but differently than we did in our layering exercise. Go to a spot where you can see a few main elements arranged, as in the boat scene (left). In your mind's eye, separate the elements into three or four main divisions. Paint each area separately, with distinctive colors. Allow the areas to dry in between, but also let some of each area overlap the earlier sections you've painted, so you can see a bit of the underlying color coming through. Take a good look at Greg's painting (left), and see whether you can figure out which section he painted first: the sky, trees, boats, or the water. You may have to try the same painting several times to get the layering and transparency that works for you. This is a good exercise to use the tube paints for because you can use them undiluted, dropping them into wet areas on the paper and letting them pool a little bit. You really want vibrancy for your overlapping layers to shine.

VARIATION

Try one where you allow the paints to bleed slightly from each of the sections, but only a little. Keep the colors strong and pure, and don't overlap, just let them touch, as in Greg's small painting of a Japanese temple (right).

Temple, watercolor

Times Square

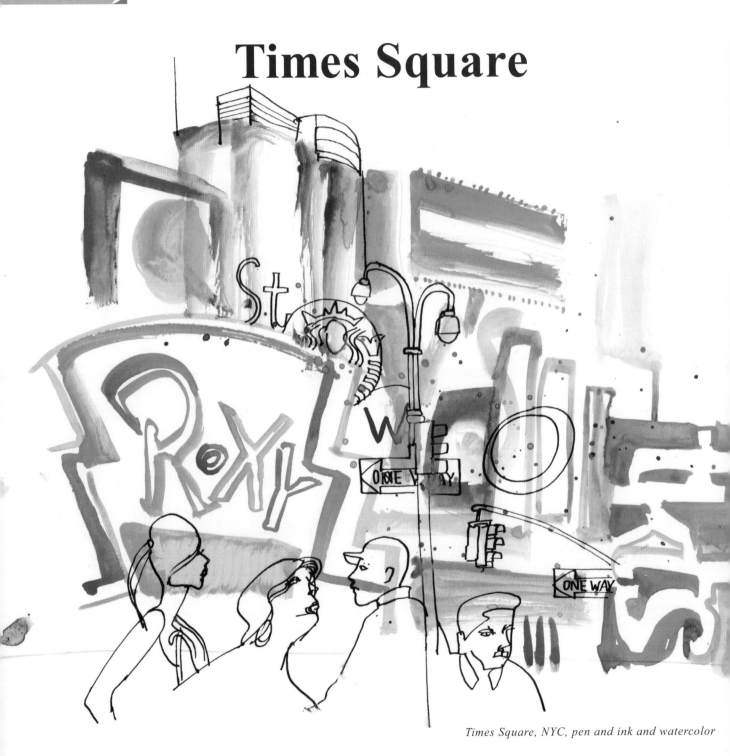

Times Square, NYC, pen and ink and watercolor

"I had a great time drawing one day at Times Square with fellow Studio 1482 members Margaret Hurst and Despina Georgiadis. We had a few laughs and some cookies and coffee besides. I enjoyed playing with the color and graphics of Times Square, as well as drawing all of the tourists. What a spectacle—the tourists are craning their heads in every direction, entertained solely by the visual stimuli of the place. Kind of the way we illustrators spend our time every day." —Veronica

EXERCISE 33

Find a place with a lot of signage. If you can't get to Times Square, try your local mall or shopping center. Using a combination of thick and thin brushes, draw the signs in bright colors with the paint. Don't feel obligated to stick to the exact placement of things; try moving the signs around to create a design that feels right to you. Once you've got your composition down, try adding a few people and details with a black line.

TIP

Use the color to draw some of the signs directly, and use it at other times to create a shape around the logo. This keeps the picture dimension moving back and forth and gives some visual interest.

Street Signs, watercolor

Sacré-Coeur

"Sacré-Coeur Cathedral, Paris. What a wonderful opportunity it was for me to be there to paint her." —Eddie

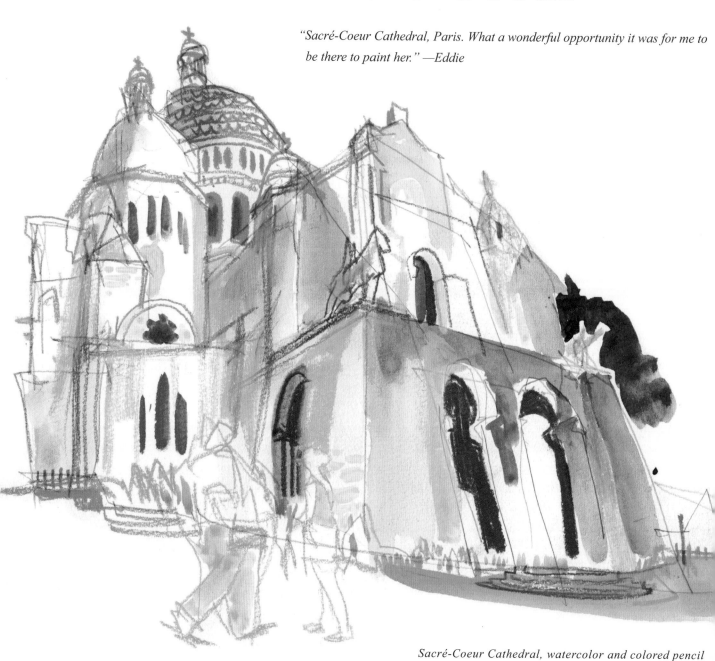

Sacré-Coeur Cathedral, watercolor and colored pencil

EXERCISE 34

Visit a local church or other architectural landmark with a strong geometric presence. Using colored pencils, draw the structure of the church. Don't hesitate to indicate the geometry of the shapes, and look at how one shape supports the other.

Once you have your basic shapes completed in your drawing, you can add the color. Be a little wild, as Eddie has done here, and play with colors that feel right as opposed to ones that represent the color you see. It might be nice to add a few people as well, for scale.

VARIATION

After you create the geometric style painting suggested above, it would be nice to do one that moves in the completely opposite graphic direction, as Michele's painting at right does. Use a Caran d'Ache crayon to draw an overall shape of the entire church. Then choose two or three analogous colors to bleed into each other within that shape. You can add a complementary color in a small area, for contrast.

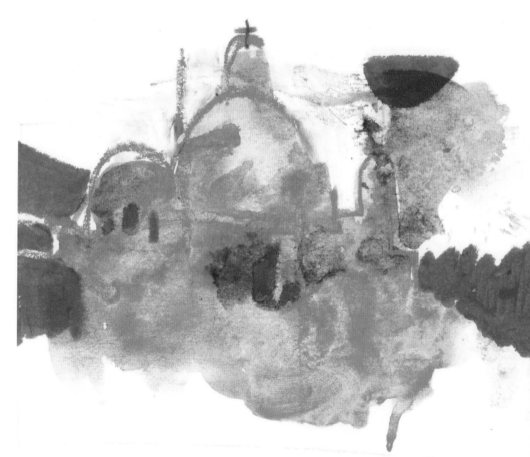

Sacré-Coeur, watercolor and Caran d'Ache crayon

Israeli Memoirs

*"Here is a collage I did two summers ago during a trip to Israel. I began
it on the spot and completed it in my hotel room. It was done during a
visit to the Western Wall, otherwise known as the 'Wailing Wall,' in the
Old City of Jerusalem. The experience was a lifetime dream realized,
and truly beyond words."* —Michele

*Western Wall, watercolor with Caran d'Ache
crayon and cut paper*

Western Wall, details, watercolor with
Caran d'Ache crayon and cut paper

TIP

One of the fun parts about working with cut paper is that you find new shapes within the bigger shapes you've cut out. Take advantage of these "happy accidents."

EXERCISE 35

This is an on-location exercise. Find a local monument or public place where people gather. Prepare some paper before you go; take several pieces of watercolor paper, and paint on them. Be expressionistic—let the different colors bleed together, splash some paint around, use your Caran d'Ache crayons for additional texture.

On location, cut the papers into shapes that represent the place you're at, and assemble a panoramic picture with it. Using your Caran d'Ache crayon, or a thin brush with drier pigment on it, add details, and create the linear people to complete the scene.

Chapter 7:
STORIES AND IDEAS

*China, by Margaret Hurst, watercolor, pencil,
oil crayon, and Caran d'Ache crayon*

Accessories

"I thought it would be fun and fashionable to highlight accessories with color." —Greg

Sunglasses and Handbag, razor-point pen and watercolor

EXERCISE 36

Find a subject that has one thing about it that you would like to highlight; it doesn't have to be people as in Greg's example. Maybe you can paint a beautiful flower in a simple vase or a decorative accent on a building—just something that catches your eye. Make a line drawing of the person, place, or thing, and use your watercolor paint to highlight one or two aspects of it. This changes the proportion of the picture and really focuses your viewer's attention. Leave the watercolor area a bit wet, and introduce other shades of that color, or a different one, into the shape, to add a little movement to the painted part.

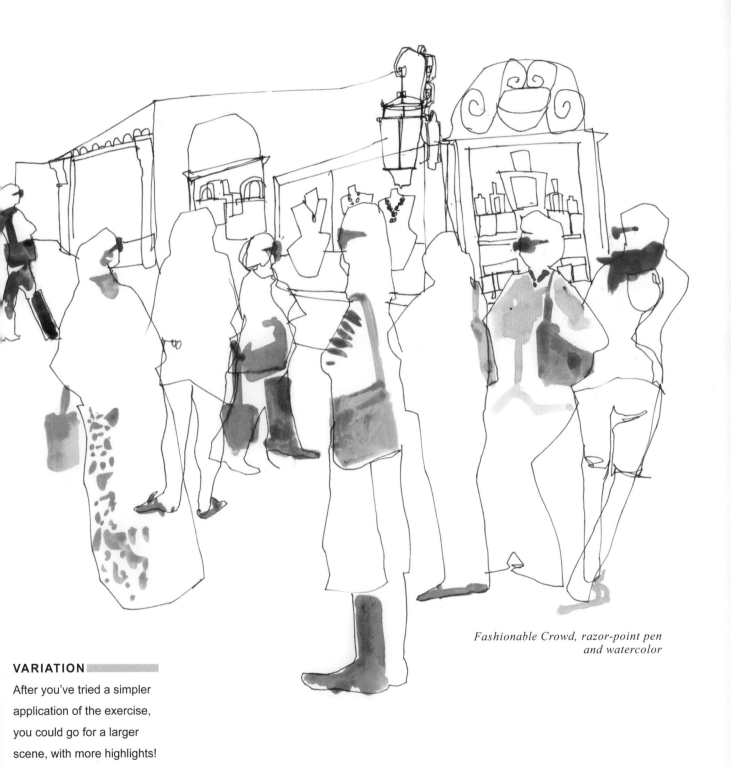

*Fashionable Crowd, razor-point pen
and watercolor*

VARIATION

After you've tried a simpler
application of the exercise,
you could go for a larger
scene, with more highlights!

Wax Drawing

*James Making a Snowman,
base drawing, pencil and marker*

"Wax drawing is pretty fun to do. I melted some candle wax and used a fine brush to paint the lines of my drawing. After the paint dried, it felt good to scrape away the wax and reveal the image. That's my little gingerbread boy playing in the snow." —Despina

EXERCISE 37

For this exercise, we are going to do a wax drawing of a special moment or memory. You could create a drawing in the moment, as Despina did while her son made a snowman, or you could find a photograph of some special memory that you would like to work from.

First, choose your paper. Here, Despina has used a 90-lb. (185 gsm) cold-press watercolor paper with some visible tooth (texture). That gives a sturdy backing for the wax, so when you scrape it off, the paper doesn't fall apart. A deckled edge adds a gallery feel.

Melt some candle wax, and using a small inexpensive paintbrush, brush your line drawing onto the paper with the melted wax. Make sure the wax is thick enough to hold the line. Once the wax has dried, layer in color to your heart's content. The beautiful thing about working with resist is that you can really play with the way you paint, and use plenty of pigment, without worrying that your image will be obscured.

When the paint has dried, scrape the wax off gently with the short end of a plastic ruler or the edge of a credit card. And there you have it—a rich and vibrant painting that makes a frame-worthy keepsake!

TIPS

Once you've designed the base drawing, you want to transfer it to your watercolor paper. One way to do it is to put the drawing on a light table and, laying the watercolor paper over it, brush the melted wax in wherever you see the line. If you don't have a light table, hold the drawing up to a television or window with bright sun coming in, and draw your line *lightly* with a hard pencil (4H or higher) on the watercolor paper. Put the melted wax line on top of that. After you scrape the wax away, you can erase the line.

Another option is to simply draw directly with the wax onto the watercolor paper, either from the photo or on location.

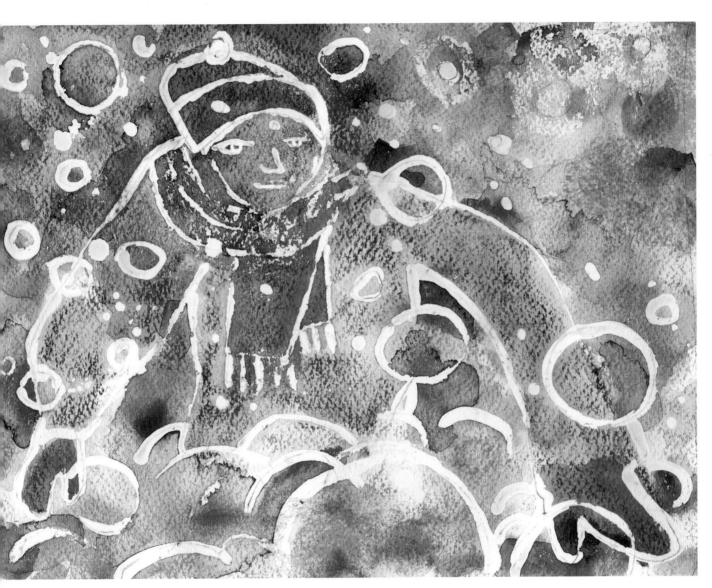

James Making a Snowman, wax resist with watercolor

Nature's Monoprint

"I have always wanted to try painting one side of a leaf or flower with watercolor paint, and then pressing it on to the paper to see what the resulting image will look like. So I tried it, and it was fun! You don't know what part will be visible until you press down on the leaf. So every attempt is a bit of serendipity! Once these two fern leaves were pressed on the paper, I decided to draw one in pencil to link them together."
—Margaret

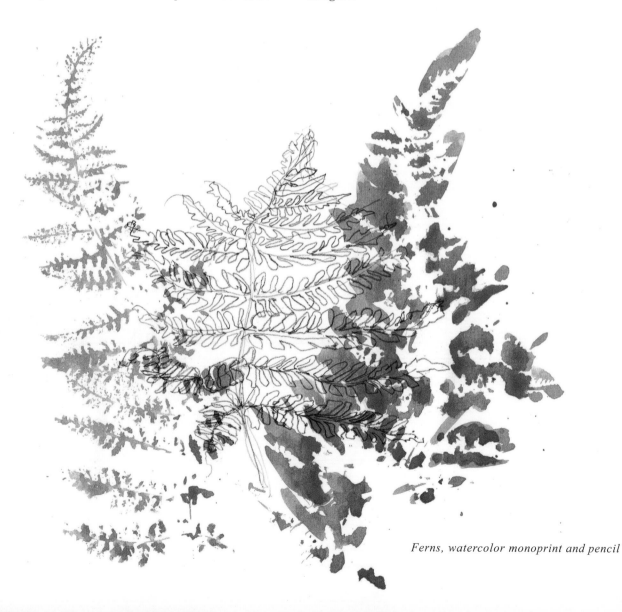

Ferns, watercolor monoprint and pencil

Leaf Abstraction, watercolor monoprint, watercolor, colored pencils

EXERCISE 38

Find a flower or leaf with an interesting shape and texture. Paint the leaf with one color or several together. Turn face down onto a piece of absorbent watercolor paper. Rice paper works well for this, too. See what kinds of designs you can create, and don't hesitate to add a little bit of pencil line drawing in there as well, to add variation of texture. Have fun!

VARIATION

Adding additional color with colored pencils and more watercolor washes is fun, too! Take an experimental approach, and see what comes of it.

Silk Painting

"I was inspired by traditional Chinese landscape paintings and the peonies in bloom to paint a landscape on silk." —Veronica

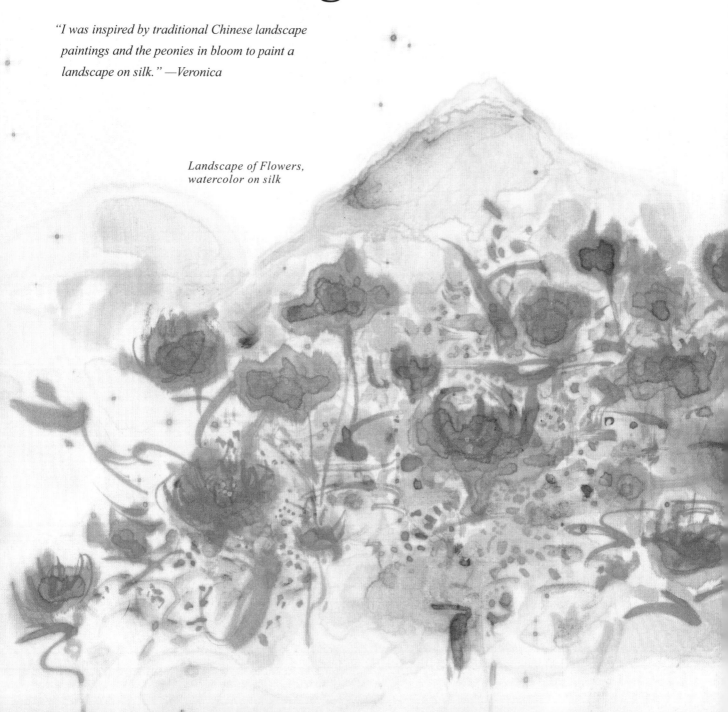

Landscape of Flowers, watercolor on silk

EXERCISE 39

To do this exercise, you'll first need a piece of silk. There are places online or physical art stores where you can purchase a 30-inch (76 cm) square scarf of China silk, which is inexpensive and perfect for this. Tape it on four sides to a piece of absorbent watercolor paper, and begin your painting. You could try a Chinese-inspired landscape, as I did, but the painting could be of anything you wish to try on silk. Notice how the paint spreads into the fabric. Make sure you put enough watercolor paint down to make up for any that will seep through to the paper below.

If you like the feel of it, try painting with some fixable silk dyes so the scarf can be washed and worn (follow the manufacturer's instructions).

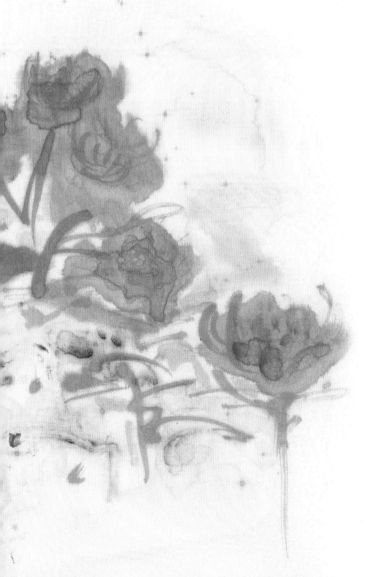

Peony, watercolor on silk

TIPS

- Start with a small scarf, and paint one flower or other simple element, as I've done above, to get a feel for how the silk accepts the paint.
- You will have to plan your larger design, because there isn't opportunity to do much layering of paint on silk. A small thumbnail will help you decide your color scheme in advance.

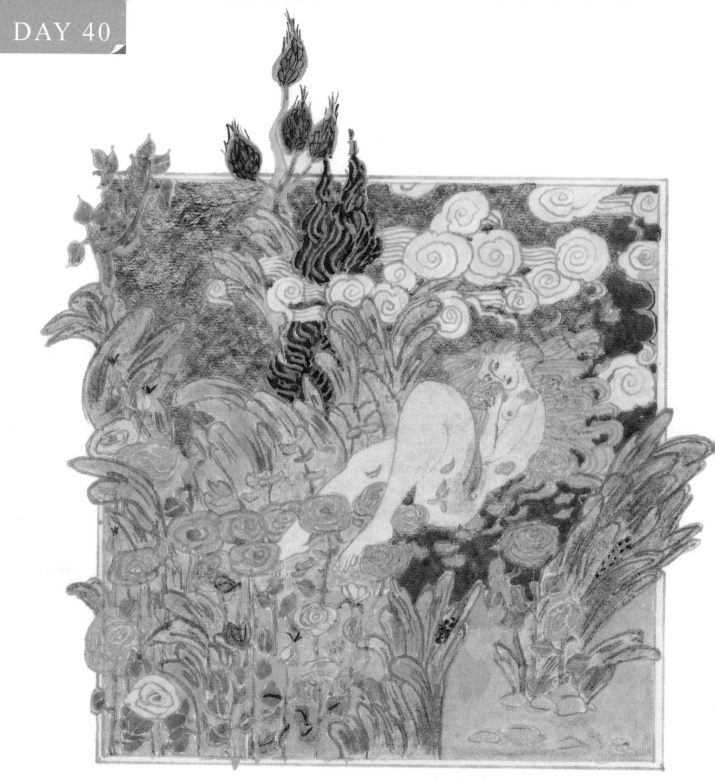

Arabian Nights, watercolor with gold paint pen

Arabian Nights

"When I was making pen and ink drawings and illustrations for the story of the Arabian Nights, *I also experimented with some color drawings and illustrations. I attempted to create the illustration under the influence of the Persian miniature paintings that I had seen at the Metropolitan Museum of Art in New York. Thought it might be fun to do!" —Margaret*

EXERCISE 40

For this cultural exercise, you'll need watercolor and a small amount of gouache. Margaret has illustrated a scene from the story of the *Arabian Nights*, but for our exercise, we'll choose a garden scene, either drawn from life or from a photo of a garden that you like.

Using a book of Persian miniature paintings as a guide (or look them up online), redesign the garden so that it takes on the stylization of a Persian miniature. Use a very thin brush with your watercolor fairly dry to get the thin lines; use a slightly larger brush and wetter pigment for the shapes. Add details over the larger shapes once dry. Again, it helps to start with lighter or less-saturated colors and add the darker or more saturated colors. A gold paint marker can add some style. Your work doesn't have to look exactly like the Persian art, just be influenced by it, to experiment.

Anansi Stories, watercolor with ink and gold paint pen

VARIATION

Once you've created the Persian-influenced garden painting, try the same picture translated through another culture, such as the illustration of a Caribbean folk tale that Margaret did (above). Take a look at the paintings from your chosen culture, and notice the way they use colors, the kinds of colors, and the amount of details in the painting. As with the Persian miniature exercise, the idea is not to copy what you're looking at, but to study the patterns of the painting and be influenced by them.

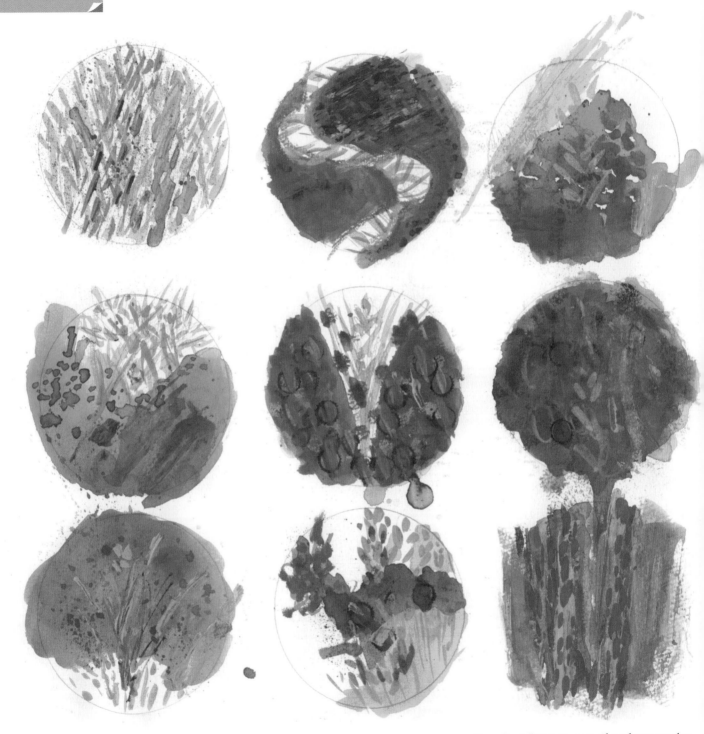

Stem Rust Designs, pencil and watercolor

Ceramic Paintings

"Before I do any painting on ceramic, I create thumbnail designs with watercolor to guide me. These are sketches for a ceramic series called Stem Rust, done in response to an outbreak of stem rust disease that infected cereal crops worldwide. I wanted to bring attention to food-related issues that we tend to overlook, since we are often far removed from the source of our sustenance." —Dominick

EXERCISE 41

Using watercolor, create thumbnails to design a set of dishes for yourself, a friend, or a family member.

Get a circle template, and create several circles on one page to paint on. Think of the colors and patterns that might work for your recipient. If you are designing dishes for your own family, for example, you might consider your cultural background, the predominant colors of favorite family places, or symbols that work. Be as literal or abstract as you want, and get experimental. Use wet color on wet paper, wet color on dry paper, dry color on dry paper, layered colors—even scratch into the paint with the back of your brush to create interesting textures and marks. Have fun with it!

Stem Rust, hand-painted ceramic

TIP

Once you've created your plate designs, check online or in the phone book to see whether there is a ceramic studio open to the public near you. Many have unfired ceramicware that you can paint on yourself, and they will fire it for you. After all that designing, wouldn't it be nice to see your dishes come to life?

My Song Is My Friend

"This is a story I wrote for my son, James. He loves to sing, and I love to hear him. So much imagination in that little boy!" —Despina

Singing, watercolor and colored pencil

EXERCISE 42

This is a painting you will make as a gift for a little person in your life: your child, grandchild, niece, nephew, friend's child, etc.—you get the idea. It's for someone less than seven years old.

Choose a classic children's song such as "Twinkle, Twinkle, Little Star," or one that the child you will give this to likes. Pull out a symbol from that song, such as a star, and make a colorful watercolor painting of it. You could mix watercolor with colored pencil as Despina has done here, or use one of the other techniques we've tried in this book. Keep the painting small; after all, you are giving it to someone with little hands. A nice white frame will help make this gift very special.

TIP
Don't overmix the colors for this one—keep them fairly pure and bright.

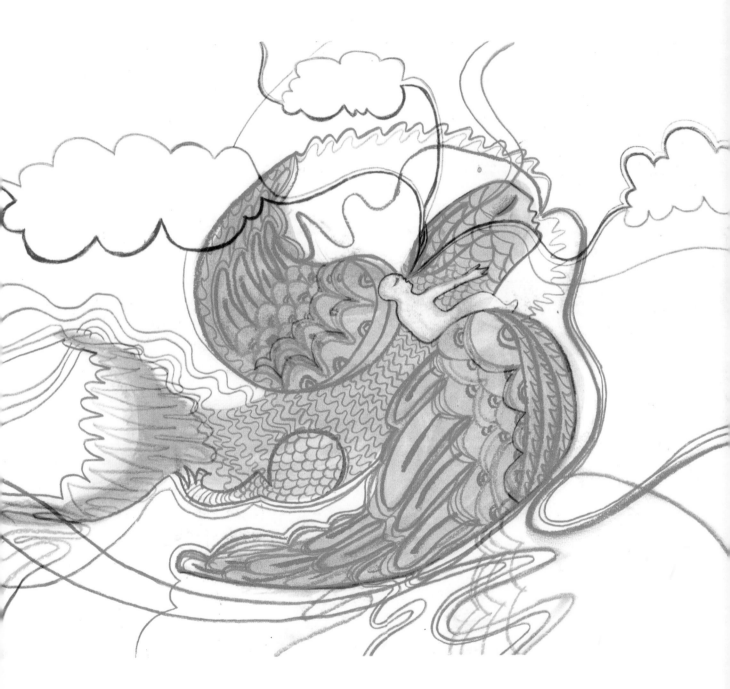

To the Sky, watercolor and colored pencil

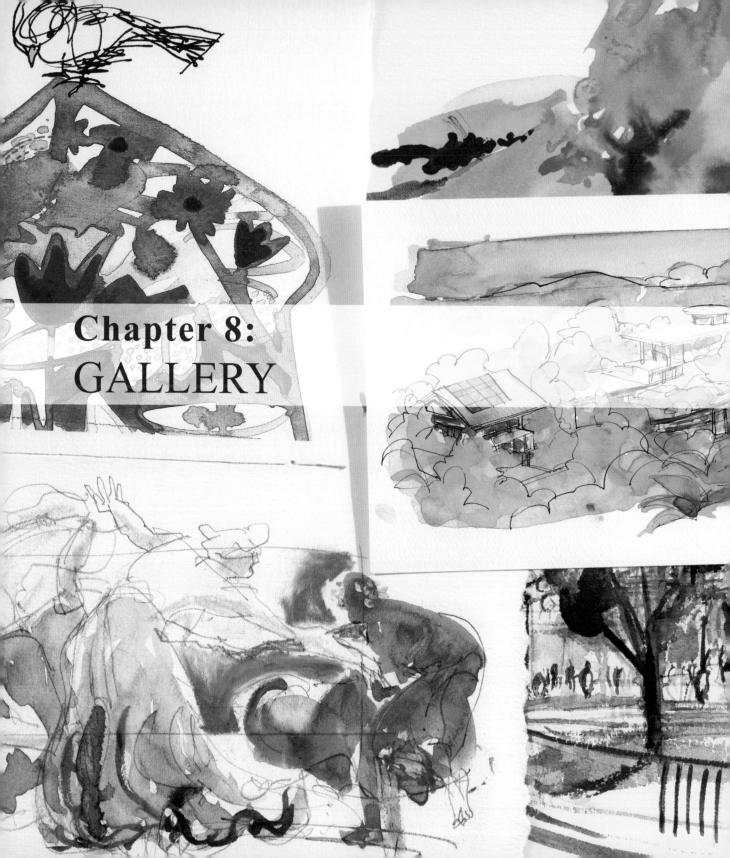

Chapter 8:
GALLERY

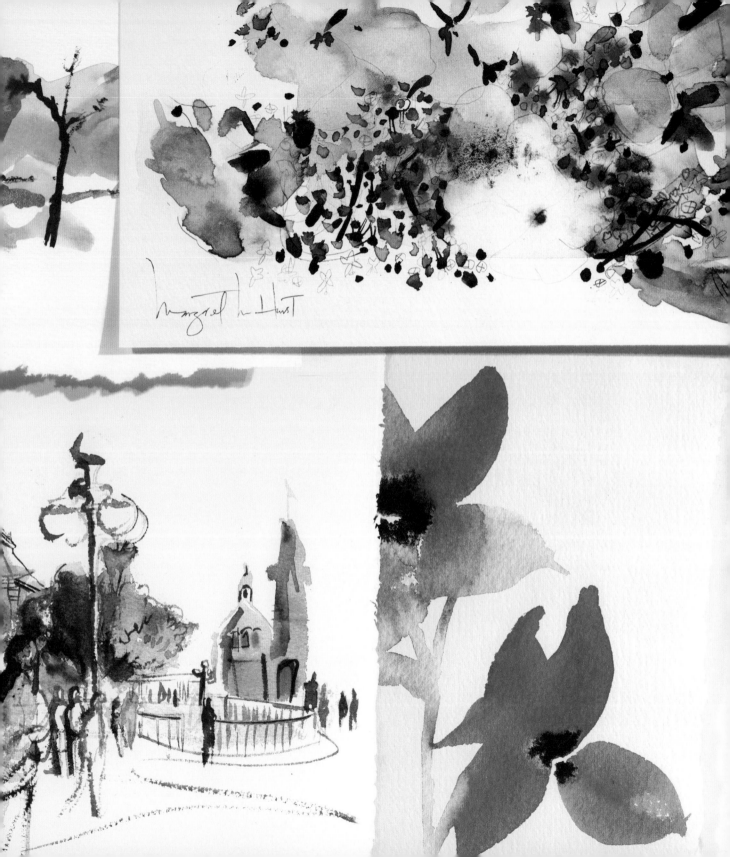

Michele Bedigian

Take unusual color combinations and interesting graphic textures, add a little knowledge and feeling for culture along with an elegant sense of design, and you get the whole picture of Michele Bedigian's work. A visual artist through and through, her work ranges from textiles to advertising, publishing to package design. Michele's communication solutions have been demanded by many top agencies, including Godiva Chocolatier, DDB Advertising, and DiNoto Advertising, as well as several publishing houses. Michele is a graduate of Parsons School of Design and the Passalacqua School of Illustration. Her watercolors have been exhibited at the Metropolitan Museum of Art and the WomanMade gallery, among other venues, and her work is sought after by numerous private collectors.

Photo by Dominick Santise

"Years back in the midst of study, I realized that, for me, the goal in my art has always been to find synergy between the way I think and the way I express thought.

I guess in all creative disciplines that stem from passion, the effort can be a risky venture. I've learned that the solution actually resides in the risk, and even more so in the mistakes. It is only there that honest growth can be revealed." —Michele

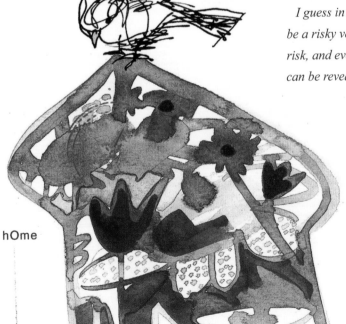

hOme

HOME, watercolor, digital, pen & ink
Home is the place I can hear the whisper clearly, and my heart is content.

HARMONY, watercolor, digital photography, pen & ink
Harmony always lies within the chaos. The key is silence. Listen, and you'll surely hear harmony's song.

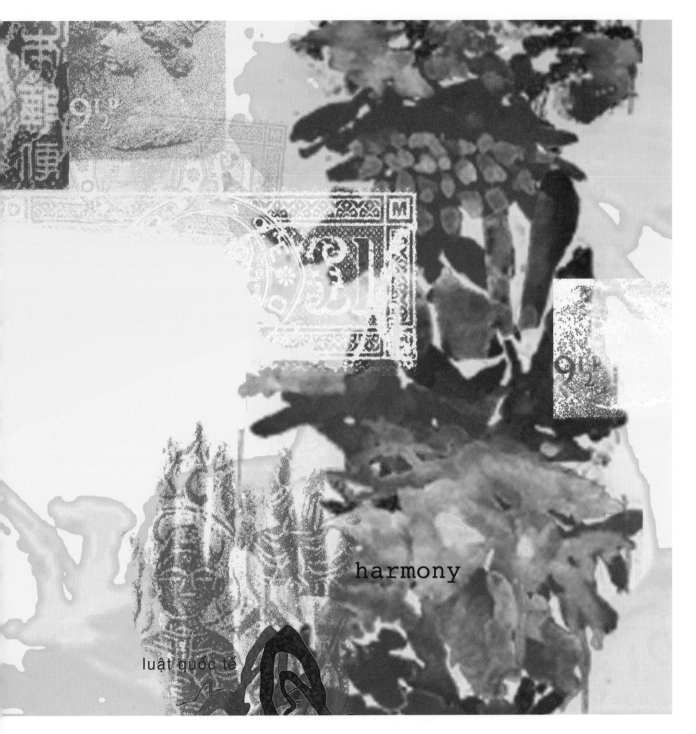

harmony

luật quốc tế

Greg Betza

Greg Betza is an illustrator, artist, and designer from New Jersey. His versatility in style and unique approach to problem solving have led him to create work for a diverse group of clients across many industries. Greg is a graduate of Parsons School of Design and has also studied extensively with the late David J. Passalacqua.

Greg has received numerous awards from institutions such as the Society of Illustrators of Los Angeles, *Communication Arts*, and *American Illustration*. In 2010, Greg was featured in *Communication Arts Fresh Online* as one of the industry's top emerging illustrators.

Photo by Greg Betza

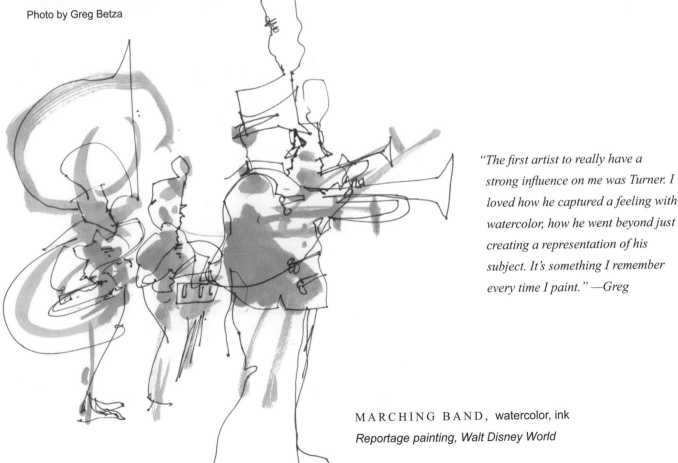

"The first artist to really have a strong influence on me was Turner. I loved how he captured a feeling with watercolor, how he went beyond just creating a representation of his subject. It's something I remember every time I paint." —Greg

MARCHING BAND, watercolor, ink
Reportage painting, Walt Disney World

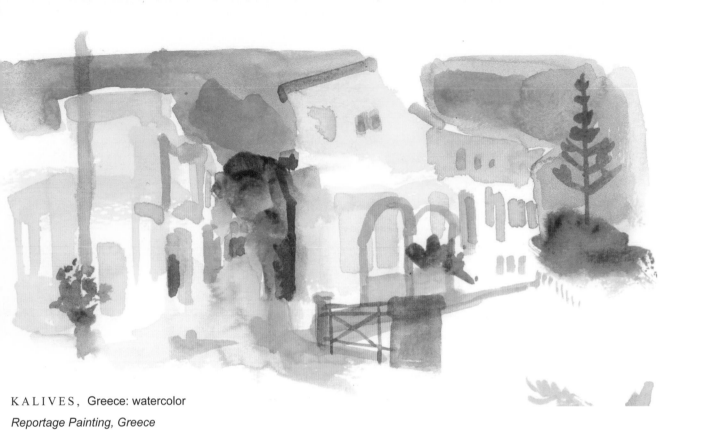

KALIVES, Greece: watercolor
Reportage Painting, Greece

SPRING FLOWER, watercolor
Concept art for a package design

Photo of Despina and son, James, by Greg Betza

Despina Georgiadis

As an illustrator, designer, and children's book creator, Despina Georgiadis loves to experiment with drawing materials and different ways of working. Despina's work has been commissioned for editorial, advertising, corporate, and web design. She enjoys teaching art to youths in the Tri-State area and is currently working on using her love of art to campaign for a change in public education.

A graduate of Parsons School of Design, Despina works from her home studio in New Jersey, which she shares with her five-year-old son, James.

"It can be just as revealing and magical drawing a street-corner scene as it is chasing an idea around the studio and wrangling it into a painting. And when working in the studio, I make sure to keep myself inspired and mindful of the great art of past and present, and cultures, and philosophies, sitting on my bookshelves." —Despina

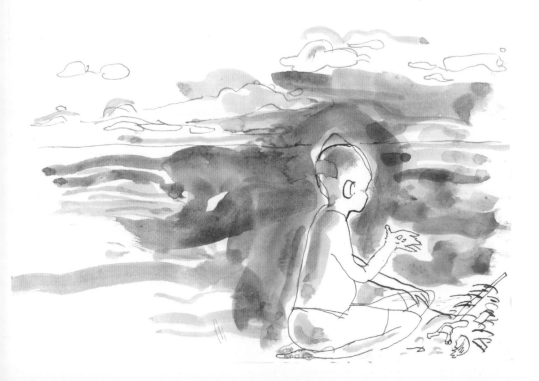

ARUBA, watercolor, sepia ink
My son, James, working on a sand castle in Aruba. Rather than taking a picture, I opted to record the moment with a drawing.

ORCHIDS, watercolor, pastel

Flowers are the perfect subject for watercolors. The way the colors blend into each other on the petals may seem impossible to capture, but a little water goes a long way for that particular task.

MAGIC KINGDOM TOWN HALL, watercolor

The Main Street in Disney World is a reflection on a special time in American history. It's a living museum, and there is much to be learned from it. Drawing and painting there is a delight.

Photo by David J. Passalacqua

Margaret Hurst

"I believe in energy. It fills us; it fills the universe. I appreciate the energy that exists in all things. It is my joy and pleasure as a visual artist to find and identify the individual energy that every being, place, and thing possesses and to manifest that particular energy into a visual form or entity."—Margaret

Margaret Hurst is a professor at Pratt Art Institute and Parsons The New School for Design and has conducted an illustration workshop at the University of Alaska. She and Veronica Lawlor are the founders of the Dalvero Academy. Margaret is a member and vice president of the Studio 1482 illustration collective. She is the author/illustrator of the award-winning book *Grannie and the Jumbie* (Laura Geringer Books) and is also a cofounder of live2lime, a Caribbean-themed fashion line.

Margaret's clients include AT&T; Neurex; Anthology/Preface; Roche; DuPont; CF Napa; Knorr; E & J Gallo; MasterCard; The Boston Group; St. Martin's Press; Stewart, Tabori and Chang; and Thomas Nelson Publishing. She has exhibited at the Society of Illustrators, the Rx Club, Messiah College, Montserrat College of Art, Tres Gallery, the Puck Gallery, and the Schaffler Gallery. Her artwork has been featured in *New York Living* and *Latitudes* magazines and is cited in the book *Early Childhood Education Today* by George S. Morrison.

A native of St. Thomas, U.S. Virgin Islands, Margaret is a graduate of Boston University and Parsons School of Design and has studied with the late David J. Passalacqua.

GIANT RUDBECKIA, watercolor, pencil
Painting and drawing flowers is a pleasure. They are alive, they are design, they are pattern and nature. I wait for them every spring!

PURPLE CORNFLOWER,
watercolor, pencil

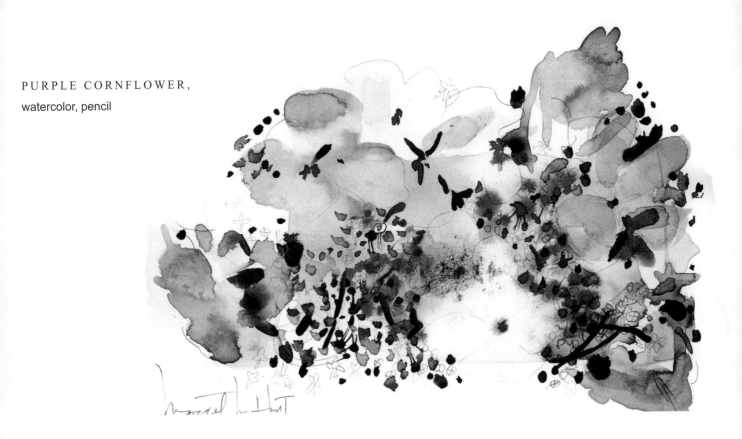

FRENCH HYDRANGEA,
watercolor, pencil

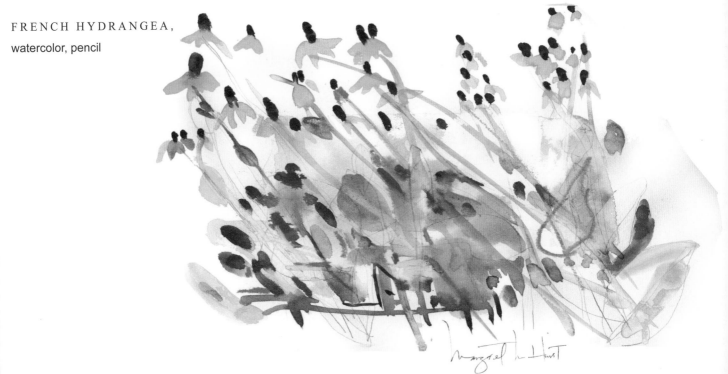

Eddie Peña

Photo by Roseanna Peña

An early lover of comic books, Eddie takes sequential storytelling to a sophisticated level with knowledge of schools, culture, and the great masters of drawing. *"Comics like the Hulk were my favorite, and instilled a love of art in me as a young man. I now find myself looking more to artists like Dürer and Brangwyn for inspiration when I go on location to draw, and when I create storyboards for film, television, and animation."*

Eddie continues sharing his knowledge of art with students as a Professor at Hostos Community College. He has been involved with programs such as F.R.E.E.D.O.M. (Free Rising with Education to Economic Development Opportunities and Mentorship), a program designed for out-of-school youth ranging from ages seventeen to twenty-one. He also worked with the New York City Parks Foundation, the only independent nonprofit that offers park programs throughout the five boroughs of New York for young people. Eddie finds joy in nurturing the young artist in each person.

THE GARDEN,
watercolor, pencil, and
Caran d'Ache crayons
*One of a series of five called,
"The Secret Garden."*

WARM SPRING,
abstract watercolor and crayon
painting depicting a day in spring

"It's not because things are difficult that we dare not venture. It's because we dare not venture that they are difficult."
—Seneca

RISK: *A situation involving exposure to danger. (Oxford English Dictionary)*

"Risk taking is a necessary component in an artist's life. Without risk, there is an extremely low chance of significant discovery in oneself and one's work. Insecurity is one of the most paralyzing diseases and greatest threat to risk. Experimenting with new tools, marks, lines, and media is what keeps me excited and anxious to work on a daily basis. Playing and never being afraid to replicate what you have created nurtures a healthy confidence needed to take calculated risks and separate you from others on the playing field. The continual practice of risk taking builds immunity to insecurity. Draw and paint things you never would, use materials that you find intimidating because you never know what you will find." —Eddie

METAMORPHOSIS,
Abstract watercolor
painting describing cellular change in the body

Dominick Santise

An artist who combines the poetic and the prosaic, illustrator Dominick Santise is also an experienced production man, a classically elegant designer, and an expressive draughtsman, animator, and photographer. His storyboards are varied and exciting in their problem solving and their choice of medium, both in the studio and on location. His clients are diverse, among them are Bristol-Myers Squibb, McCann Erickson, Pointed Leaf Press, *Inc.* magazine, Gruner and Jahr, and Pace Communications. His 2005 reportage of the American Museum of Natural History's dinosaur exhibit was featured in *New Scientist* magazine. Recently, Dominick has turned his personal time and attention to the subjects of agriculture and the environment, starting the artisanal ceramic plate project Terra Messor and contributing to the blog theenvironmentalobstacle.org.

Dominick is the author/illustrator of several stories, including *Beneath the Tree*, and has been working on images for the book *Spring Tea Party*, written by his late grandmother. He lives in the mid–Hudson Valley with his wife and daughters.

Photo by Dominick Santise

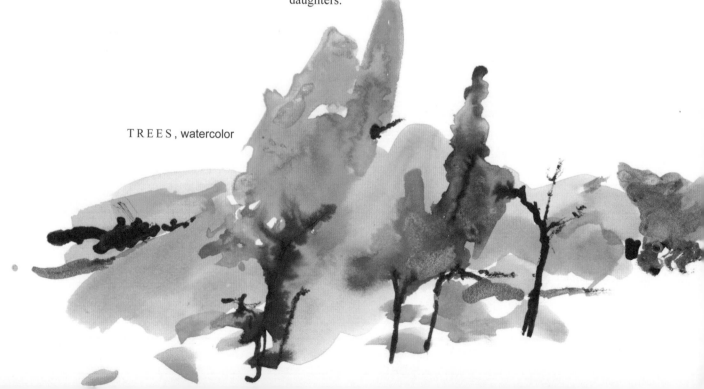

TREES, watercolor

CHARTRES CATHEDRAL,
watercolor

"When words fail, the pen and brush go to the paper. The journey has been bright thus far; I long to continue—to draw, to paint, to find. New worlds created from the movement of the hands. To share the stories and speak of the moments that would otherwise pass us by if not for the simple compulsion to mark a piece of paper with line and color. Each day's experience builds on the thousands before." —Dominick

FALL, watercolor, sepia ink

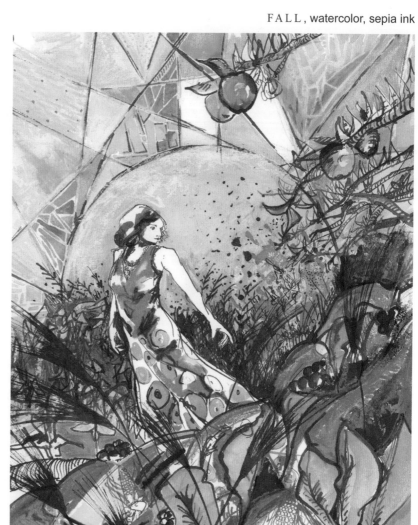

Photo by Neil Weisenfeld

Veronica Lawlor

Veronica Lawlor is an artist and illustrator whose reportage drawings have led her around the world, completing campaigns for a diverse group of clients. Her work has been exhibited internationally, and her reportage illustration is part of the permanent collection of the Newseum in Washington, D.C. In 2011, Veronica was honored as the North American nominee for the Canson Prix, and her work was presented at the Louvre. Ms. Lawlor's books include *I Was Dreaming to Come to America: Memories of the Ellis Island Oral History Project* (Viking Press); *September 11, 2001, Words and Pictures* (vero press); and *One Drawing a Day: A 6-Week Course with Illustration and Mixed Media* (Quarry Books). Other exhibits and honors include The United Nations, The Society of Illustrators, American Illustration, and the Ellis Island Museum of Immigration. Veronica's work has appeared in numerous publications.

"Drawing and painting is about love and passion. Without those, there is no art. I am so gratified to have the ability to spend my life doing what I feel passionate about, and passing that love on to my students. Drawing and painting is an honest way to see the world and to hopefully show others the beautiful world that I see." —Veronica

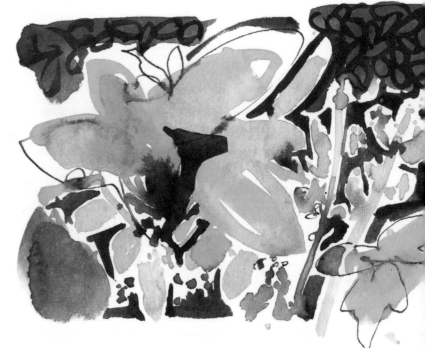

NYBG FLOWERS, watercolor

ISLE SIMCA, Panama: watercolor, ink

SUNSET IN THE PARK, watercolor, ink

Veronica is the president of Studio 1482 and a correspondent for the Urban Sketchers international sketch blog. As an educator, Veronica is on the faculty of Pratt Institute and Parsons The New School for Design, and is a cofounder of the Dalvero Academy.

A graduate of Parsons School of Design and a student of the late David J. Passalacqua, she also holds a masters in media arts from the New School. Veronica is the author of *One Watercolor a Day*.

Acknowledgments

Thank you to the members of Studio 1482 for entrusting me with their watercolor paintings: Michele Bedigian, Greg Betza, Despina Georgiadis, Margaret Hurst, Eddie Peña, and Dominick Santise. It's nice to have an art family. We all would thank our teacher, Dave, for bringing us into this fabulous life of art.

Much appreciation goes to Mary Ann Hall for giving us this opportunity and for being such an encouraging and enthusiastic editor. Thank you to Canson paper for their generous donation of the Arches Watercolor Paper used in this book, and for their constant support of artists and art students.

Thanks go also to my family for their encouragement, and to my wonderful students for their support and friendship. Lastly, thank you to my husband, Neil, without whom I would feel much more alone in this big, big world.

Flowering Tree, by Veronica Lawlor, watercolor